COOL SHOPS
BERLIN

teNeues

Imprint

Editor:	Sabina Marreiros
Editorial coordination:	Mathias Breithack
Photos (location):	Markus Bachmann (Best Shop, blush Dessous, Bramigk, Bücherbogen Knesebeckstraße, Claudia Skoda, dazu, dopo domani, Dussmann das KulturKaufhaus, Fiona Bennett, gut und schön, Ito. The Berlin Shop, Lisa D., lucid21, Mane Lange, Nanna Kuckuck – Haute Couture, Quartier 206, R.S.V.P, Respectmen, Schmuck Anziehen, Studio John De Maya, thatchers, Trippen Flagship store, Villa Caprice, Whisky & Cigars, ZUMTOBEL STAFF Lichtzentrum Berlin), Daniel Breidt (Modeagentur Klauser), Cosimo Buccolieri (I Pinco Pallino), Barbara Burg (Bücherbogen Nationalgalerie), Courtesy Aveda Institute Berlin (Aveda Lifestyle Salon & Spa), Courtesy Hut Up (Hut Up Berlin), Courtesy in't Veld Schokoladen (in't Veld Schokoladen), Courtesy Porsche Design (Porsche Design Store), Palladium (Bücherbogen Nationalgalerie), Anette Petermann (Anette Petermann), Martina Sauter (NIX), Oliver Schuh (Bücherbogen Nationalgalerie)
Introduction:	Heinfried Tacke
Layout & Pre-press:	Thomas Hausberg
Imaging & Map:	Jan Hausberg
Translations:	SAW Communications, Dr. Sabine A. Werner, Mainz Céline Verschelde (French) Silvia Gomez de Antonio (Spanish) Elena Nobilini (Italian) Dr. Suzanne Kirkbright (English)

Produced by fusion publishing GmbH Stuttgart . Los Angeles
www.fusion-publishing.com

Published by teNeues Publishing Group

teNeues Publishing Company
16 West 22nd Street, New York, NY 10010, USA
Tel.: 001-212-627-9090, Fax: 001-212-627-9511

teNeues Book Division
Kaistraße 18, 40221 Düsseldorf, Germany
Tel.: 0049-(0)211-994597-0, Fax: 0049-(0)211-994597-40

teNeues Publishing UK Ltd.
P.O. Box 402, West Byfleet, KT14 7ZF, Great Britain
Tel.: 0044-1932-403509, Fax: 0044-1932-403514

teNeues France S.A.R.L.
4, rue de Valence, 75005 Paris, France
Tel.: 0033-1-55766205, Fax: 0033-1-55766419

teNeues Iberica S.L.
Pso Juan de la Encina, 2-48. Urb Club de Campo
28700 S.S.R.R., Madrid, Spain
Tel./Fax: 0034-91-6595876

www.teneues.com

ISBN:	3-8327-9070-5

© 2005 teNeues Verlag GmbH + Co. KG, Kempen

Printed in Italy

Bibliographic information published by Die Deutsche Bibliothek.
Die Deutsche Bibliothek lists this publication in the Deutsche Nationalbibliografie; detailed bibliographic data is available in the Internet at http://dnb.ddb.de.

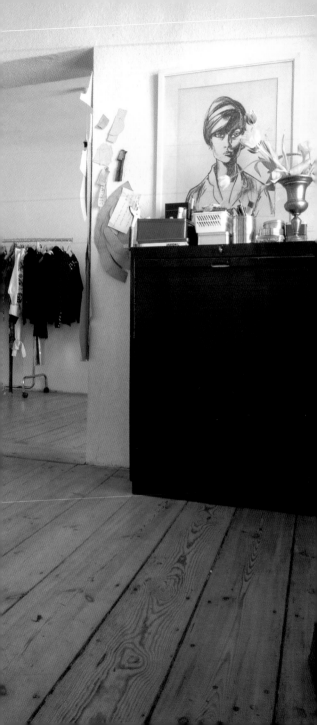

Einleitung

Potsdamer Platz, Berlin Mitte, Prenzlauer Berg, Friedrichshain – in welcher anderen Stadt machen Architektur und Kultur eine ähnlich rasante Entwicklung durch wie in Berlin? Kaum mehr als 15 Jahre ist es her, da war die Spreemetropole eine ummauerte Städteinsel, deren Wachstum unweigerlich durch eine beklemmende Enge gehemmt wurde. Doch mit dem Fall der Mauer haben sich die Fesseln gelöst. Dieses Ereignis macht Berlin, wie es heute ist, erst möglich. Es prägt diese Stadt, in der es angesichts der Gleichzeitigkeit von Eröffnungen hier, Events da und tausend innovativen Projekten unmöglich scheint, überall dabei zu sein. Berlin ist zu einem Magneten kultureller Kreativität aufgestiegen. Nicht nur die Fashionszene entdeckt die alte und neue Hauptstadt für sich. Gerade junge Labels präsentieren sich frech mit lässig-unverkrampftem Stil- und Selbstbewusstsein. In renovierten Höfen und wieder hergerichteten Brachen schießen die Showrooms nur so aus dem Boden. Wer kann da noch all die jüngst eröffneten Läden überblicken, ob sie nun in der Friedrichstraße, am Gendarmenmarkt, in den Hackeschen Höfen oder den angesagten Szenevierteln im Osten der Stadt liegen?

Das macht die Shopping- und Bummeltour durch Berlin zu einem Ereignis. Egal, was das Objekt der Begierde ist. Beim Stöbern durch die reanimierten Einkaufszeilen spürt man den Puls der Zeit, als würde man direkt den Finger draufhalten. Puristische Gestaltung wechselt sich ab mit cooler Inszenierung, witzigste Ideen paaren sich mit der Obsession für das Produkt. Ob Hutgalerie, Schokoladenshop, Bar mit Möbeln und Bekleidungsboutique oder Shirtdesignstübchen. Es ist dieser Mix aus Produktideen und gekonnter Präsentation, aus dem dieses gewisse Etwas entsteht.

Cool Shops Berlin bietet einen Querschnitt durch die aktuellsten Läden Berlins, die – so unterschiedlich sie in Konzeption, Stilrichtung und im Warenangebot sind – eines gemeinsam haben: Ganz gleich, ob man mit prallen Tüten aus den Shops herausläuft oder nicht, auf jeden Fall wird man ihn mit dem nachhallenden Gedanken verlassen: cooler Laden. Das Erlebnis zählt. Und das ist in dieser Metropole, die sich seit geraumer Zeit immer wieder neu erfindet, garantiert.

Heinfried Tacke

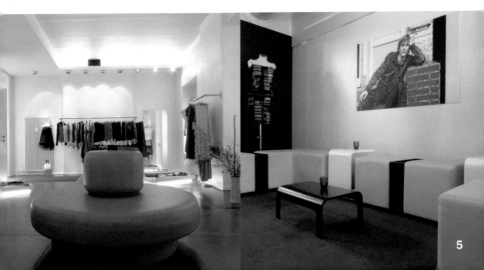

Introduction

Potsdamer Platz, Berlin-Mitte, Prenzlauer Berg, Friedrichshain—which other city has undergone such rapid development in architecture and culture as Berlin? Hardly more than fifteen years have passed since the metropolis on the Spree was fenced in on all sides by a wall. This was an island city, whose growth was inevitably stunted by a stifling atmosphere of claustrophobia. But since the fall of the Berlin Wall, the chains have loosened.

It's thanks to this event that Berlin as we know it today was possible at all. It influences this city, where so many things happen at the same time, like openings here, events there, and thousands of innovative projects—it seems impossible to be everywhere. Berlin has risen to new heights as a magnet of cultural creativity. Not only the fashion world is discovering the old and new capital city for itself. Young designers, especially, are bursting onto the scene in a provocative way with a casual, uninhibited style and self confidence. Showrooms are sprouting up like nothing in renovated courtyards and derelict sites that are now restored. Who knows the whole story about all the recently opened shops, whether they are on the Friedrichstraße, at the Gendarmenmarkt, in the Hackesche Höfe or the popular trendy quarters in the east of the city?

That makes a shopping trip and a leisurely stroll through Berlin into an event, never mind what item you wish to purchase. While you are looking around the rejuvenated shopping areas, you can feel the pulse of the time, as if you had your finger right on it. Purist design intermingles with cool interiors and the funniest ideas go hand in hand with an obsession for the product. It doesn't matter whether it's a hat store, chocolate shop, bar with furniture and clothing boutique or a small designer shirt outlet. It is this mix of product ideas and skilful presentation that creates that certain something.

Cool Shops Berlin offers a sample of the most up-to-date shops in Berlin. As different as they are in their conception, style and choice of items for sale, they have one thing in common: it doesn't matter whether you walk out of the shops with heavy bags, you are bound to leave with the lasting thought: a cool shop. The experience is what counts. For some time, this metropolis has been constantly reinventing itself. You are guaranteed to enjoy the experience.

Heinfried Tacke

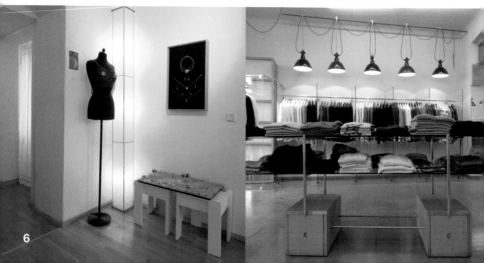

Introduction

Potsdamer Platz, Berlin Mitte, Prenzlauer Berg, Friedrichshain : dans quelle autre ville l'architecture et la culture connaissent-elles un développement aussi rapide qu'à Berlin ? Il y a 15 ans à peine, la métropole fondée au bord de la Spree était encore une île urbaine entourée de murs dont la croissance était inévitablement bloquée par une étroitesse oppressante. Mais avec la chute du mur, ses fers se sont brisés. Cet évènement a permis à Berlin de s'affirmer telle qu'elle existe aujourd'hui. Il marque cette ville dans laquelle il semble impossible d'être partout, tant ont lieu simultanément des inaugurations par-ci, des festivals et des milliers de projets innovants par-là. Berlin est devenu un aimant de créativité culturelle. Ce n'est pas seulement la scène de la mode qui utilise l'ancienne et la nouvelle capitale en sa faveur. Ce sont précisément de jeunes marques qui se présentent avec impertinence dans un style nonchalant et relaxe. Les salles d'exposition surgissent du sol en un rien de temps, dans des cours rénovées et sur des friches réaménagées. Qui peut encore avoir une vue d'ensemble de toutes les boutiques ouvertes récemment, que ce soit dans la Friedrichstraße, sur le Gendarmenmarkt, dans les Hackesche Höfe ou les quartiers branchés de l'Est de la ville ?

Faire son shopping et ses emplettes à Berlin devient un évènement particulier, quel que soit l'objet recherché. Lorsque l'on flâne dans les passages commerçants qui ont retrouvé leur animation, on ressent le pouls du temps comme si notre doigt était directement posé dessus. Un aménagement puriste est alterné par une mise en scène décontractée, des idées amusantes et piquantes se joignent à l'obsession du produit. Qu'il s'agisse d'une galerie à chapeaux, d'un magasin de chocolat, d'un bar avec des meubles et une boutique vestimentaire ou d'une petite pièce présentant des chemises design. C'est ce mélange d'idées de produits et de savoir-faire en matière de présentation qui crée ce petit quelque chose si particulier.

Cool Shops Berlin offre une vue en coupe des magasins les plus actuels de Berlin qui, même s'ils se distinguent par leur conception, leur style et la marchandise qu'ils proposent, ont une chose en commun : que l'on ressorte ou non des magasins avec des sacs plein à craquer, on le quittera en tout cas avec une impression qui nous poursuivra longtemps : cool, cette boutique. C'est la chose vécue qui compte. Et c'est ce que garantit cette métropole qui se réinvente constamment depuis si longtemps.

Heinfried Tacke

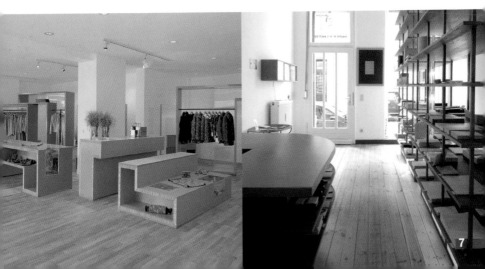

Introducción

Potsdamer Platz, Berlin Mitte, Prenzlauer Berg, Friedrichshain, en ninguna otra ciudad la arquitectura y la cultura están experimentando un desarrollo tan vertiginoso como en Berlín. Hace apenas 15 años, la metrópoli a orillas del Spree era una isla rodeada por un muro cuyo crecimiento estaba siendo irremisiblemente ahogado por una asfixiante estrechez. Pero con la caída del muro se han roto las cadenas.

Este acontecimiento histórico ha hecho posible que Berlín se haya convertido en lo que hoy es. La simultaneidad de las inauguraciones, la celebración de encuentros y los miles de innovadores proyectos, hace que parezca imposible poder estar presente en todos los acontecimientos. Berlín se ha transformado en un imán de la creatividad cultural. Pero el mundo establecido de la moda no es el único que ha descubierto y conquistado para sí la vieja y nueva capital. Son precisamente las marcas jóvenes las que se presentan de una forma descarada con un estilo y una seguridad desenfadados. Las locales surgen de la nada en los patios y en los solares acondicionados. Es prácticamente imposible conocer todas las tiendas inauguradas en los últimos tiempos; en la Friedrichstraße, en el Gendarmenmarkt, en los patios Hackesche Höfe o en los barrios de moda en la parte este de la ciudad.

Esta innumerable cantidad de locales hace que ir de tiendas en Berlín se convierta en toda una experiencia, sea cual sea el objeto que estemos buscando. Paseando por las reanimadas calles comerciales podemos sentir el pulso del tiempo en nuestros dedos. El diseño purista se alterna con una escenificación moderna, las ideas más ocurrentes van ligadas a la obsesión por el producto. Tiendas de sombreros, de chocolate, bares con exposiciones de muebles y boutiques de ropa o pequeñas tiendas donde se diseñan camisetas. Es esta mezcla de ideas y el ingenio en su presentación lo que convierte los comercios de Berlín en lugares fascinantes.

Cool Shops Berlin le ofrece un recorrido por las tiendas más actuales de Berlín que, aun difiriendo en su concepción, en su estilo y en sus productos, tienen una característica en común: todas impresionan por genialidad, tanto si compramos en ellas como si solo entramos para mirar. Lo importante es la experiencia, algo que esta ciudad en continuo cambio siempre nos garantiza.

Heinfried Tacke

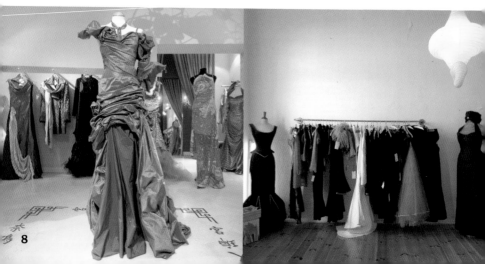

Introduzione

Potsdamer Platz, Berlin Mitte, Prenzlauer Berg, Friedrichshain – in quale altra città architettura e arte stanno vivendo di pari passo uno sviluppo così rapido come a Berlino? Sono passati poco più di 15 anni da quando la metropoli sul fiume Sprea era ancora una città-isola circondata da un muro e la cui crescita era immancabilmente frenata da un'opprimente strettezza. Con la caduta del muro, poi, questo freno si è allentato.

Questo avvenimento ha segnato la svolta che ha permesso a Berlino di diventare la città che è oggi. Esso ha influenzato profondamente questa città, in cui per la coincidenza di inaugurazioni, di eventi e di mille progetti innovativi, sembra impossibile arrivare ovunque per prenderne parte. Berlino è diventata un polo d'attrazione di creatività culturale. Non è il solo mondo della moda affermata a riscoprire la vecchia e nuova capitale. Sono in particolare le nuove griffe, infatti, che, in modo sbarazzino, si propongono qui con disinvoltura e con uno stile spigliato. In cortili restaurati e aree incolte rimesse in sesto, gli show room spuntano come niente. Ma chi riesce a tenere il conto di tutti gli ultimissimi negozi aperti, che siano nella Friedrichstraße, sulla piazza del Gendarmenmarkt, negli Hackeschen Höfe o nei quartieri alla moda della zona est della città?

Ecco perché girare per Berlino a vedere le vetrine e a fare shopping si trasforma in un vero avvenimento, qualunque sia l'oggetto del desiderio. Curiosando per le rianimate viuzze di negozi si avverte il battito del tempo, come a tenervi il dito appoggiato sopra. Forme puristiche si alternano a vetrine eccentriche, idee molto spiritose si accompagnano all'ossessione per il prodotto. Sia che si tratti di gallerie di cappelli, negozi di cioccolato, bar con mobili e boutique d'abbigliamento, o negozietti di t-shirt firmate, è proprio questo mix di idee di prodotti e abili presentazioni a dar vita a questo certo non so che.

Cool Shops Berlin offre una rassegna dei negozi più attuali di Berlino, che pur così diversi per progettazione, tendenza stilistica e merce offerta, hanno comunque qualcosa che li accomuna. Con sacchetti pieni o a mani vuote, il pensiero insistente che ci accompagnerà uscendo da questi negozi sarà uno: un negozio fantastico! L'avventura conta. E in questa metropoli, che da tempo si reinventa continuamente, l'avventura è garantita.

<div align="right">Heinfried Tacke</div>

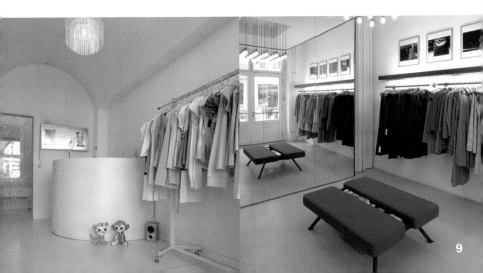

Anette Petermann

Design: Anette Petermann

Bleibtreustraße 49 | 10623 Berlin | Charlottenburg
Phone: +49 30 3 23 25 56
www.anette-petermann.de
Opening year: 1998
Subway: Savignyplatz
Opening hours: Mon–Fri 11 am to 7 pm, Sat 11 am to 6 pm
Products: Self made women's fashion, accessories, bags, corsages, collection
'Lieblinsstücke'
Special features: Showroom with own collection by Anette Petermann

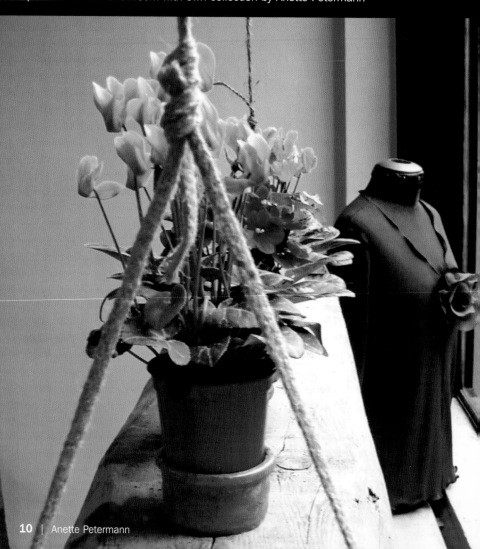

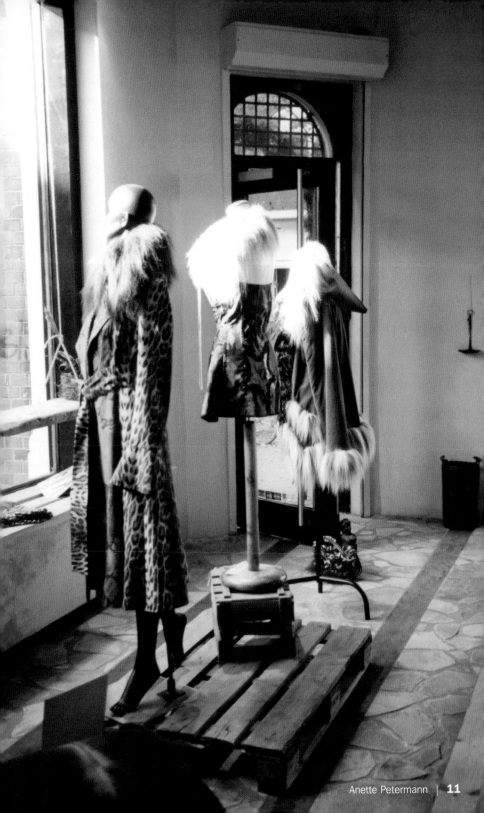

Aveda Lifestyle Salon & Spa

Design: Jamie Fobert, Carola Schäfers

Kurfürstendamm 26a | 10719 Berlin | Charlottenburg
Phone: +49 30 88 70 87 99
www.aveda.com
Opening year: 2003
Subway: Uhlandstraße
Opening hours: Mon–Fri 10 am to 8 pm, Sat 9 am to 6 pm, or call for appointment
Products: Natural haircare, skin & bodycare, lifestyle products

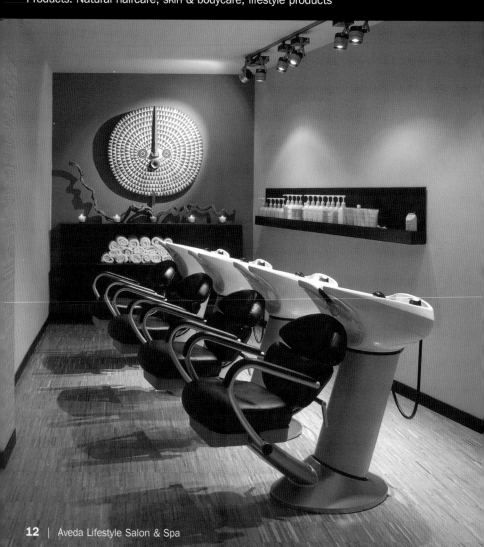

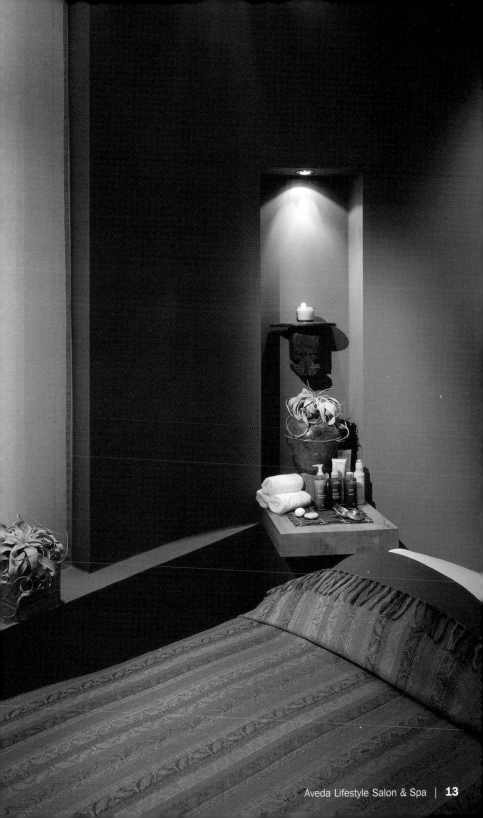

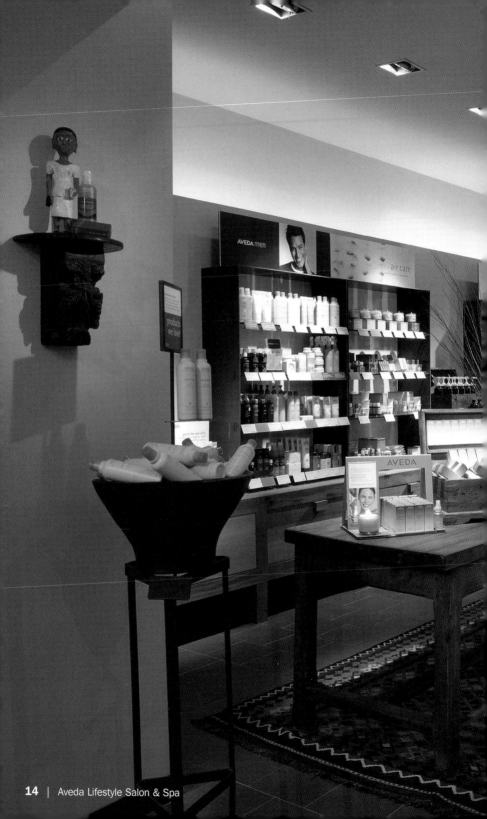

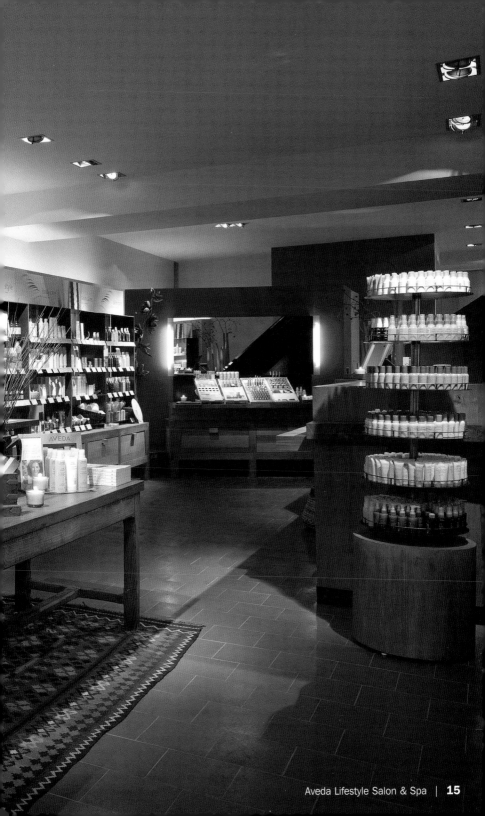

Best Shop

Design: Hanno Bäucker / Vektorfarm

Alte Schönhauser Straße 6 | 10119 Berlin | Mitte
Phone: +49 30 24 63 24 85
www.bestshop-berlin.de
Opening year: 2004
Subway: Rosa-Luxemburg-Platz
Opening hours: Mon–Sat noon to 8 pm
Products: Fashion, music, books, art

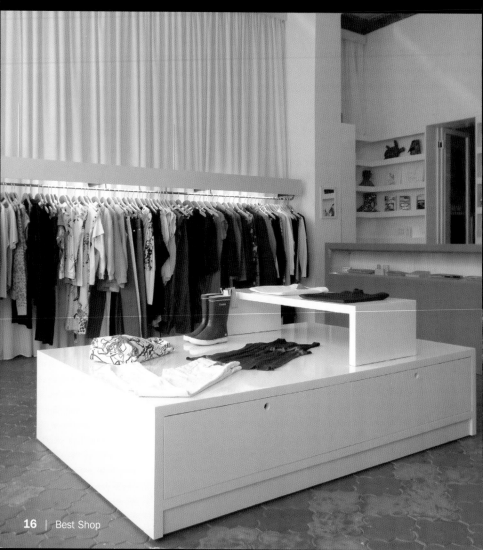

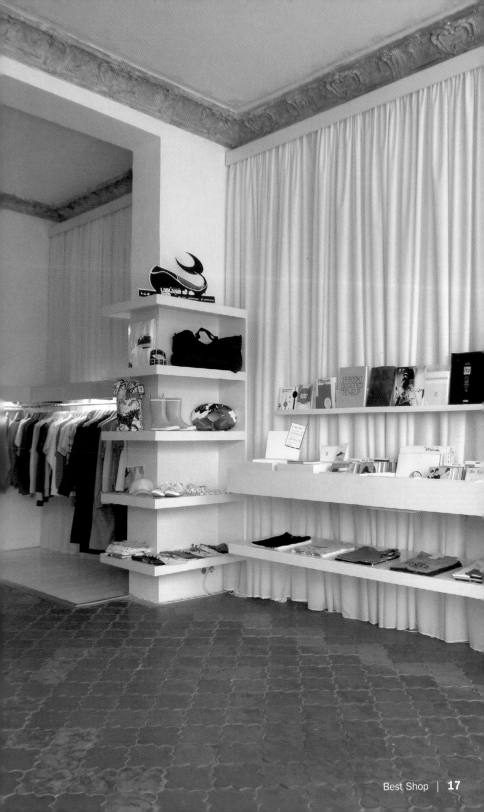

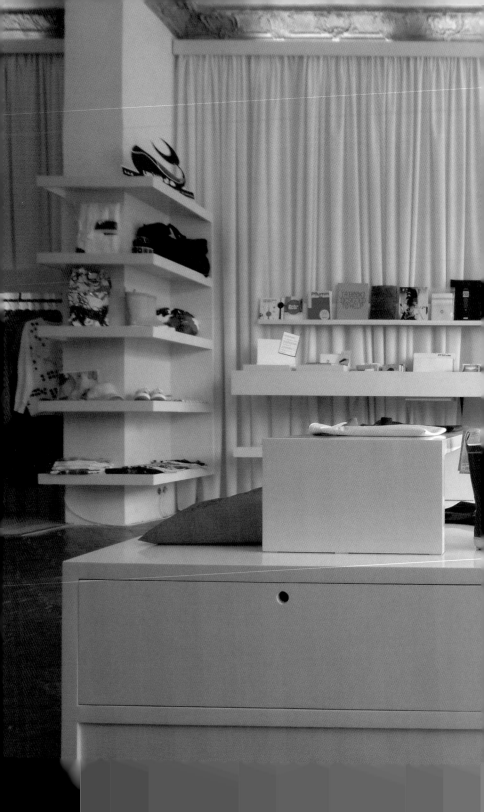

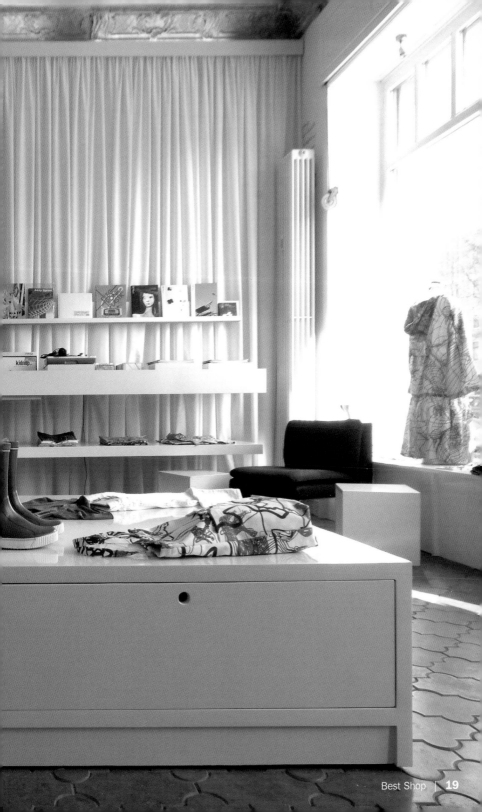

blush Dessous

Design: Carsten Wiewiorra, Claudia Kleinert

Rosa-Luxemburg-Straße 22 | 10178 Berlin | Mitte
Phone: +49 30 28 09 35 80
www.blush-berlin.com
Opening year: 2001
Subway: Rosa-Luxemburg-Platz, Alexanderplatz
Opening hours: Mon–Fri noon to 8 pm, Sat noon to 7 pm
Products: Dessous, nightwear, sleeping masks, tights (nylons)

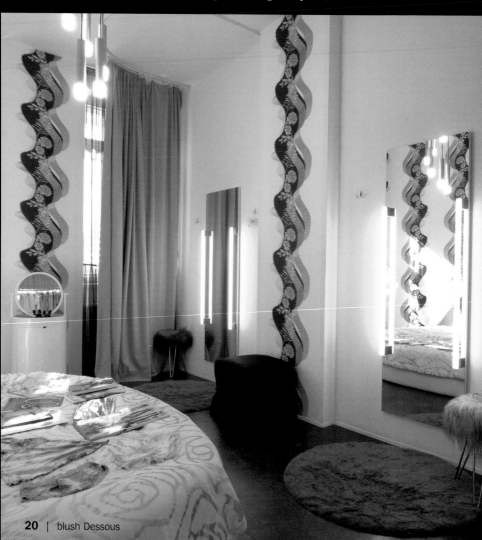

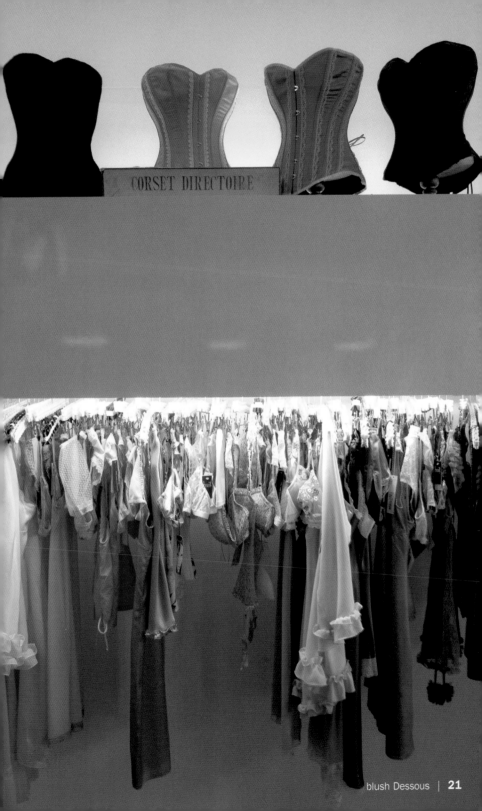

CORSET DIRECTOIRE

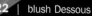

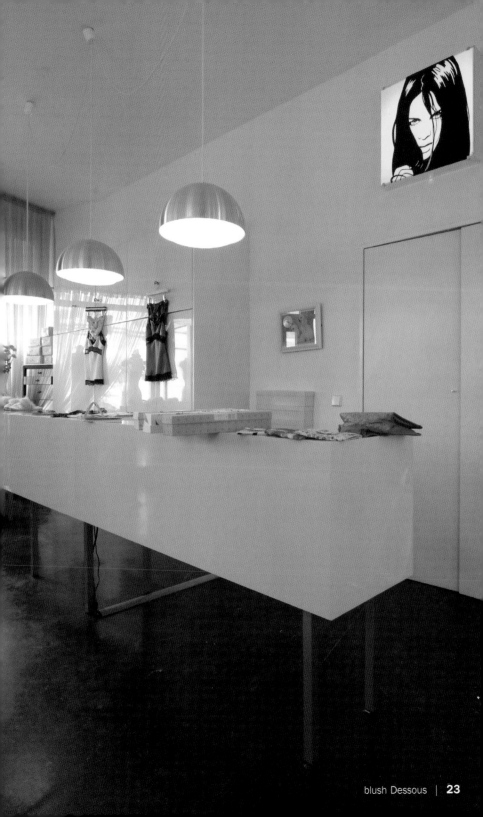

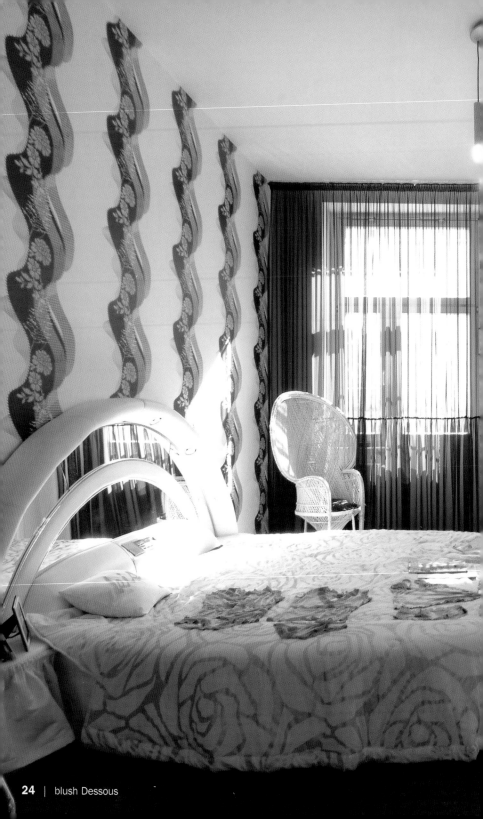

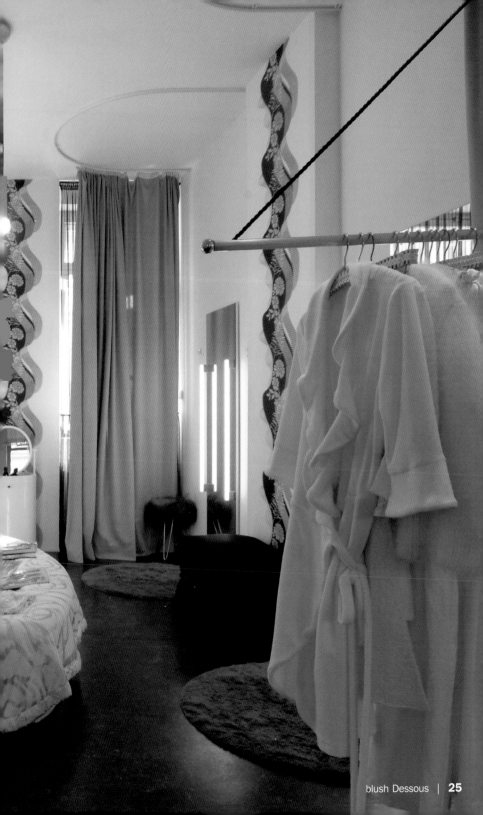

Bramigk

Design: Nicola Bramigk

Savignypassage Bogen 598 | 10623 Berlin | Charlottenburg
Phone: +49 30 3 13 51 25
www.bramigk-design.de
Opening year: 1989
Subway: Savignyplatz
Opening hours: Mon–Fri 11 am to 6:30 pm, Sat 11 am to 4 pm
Products: Women's fashion, casual wear, knitted shirts and t-shirts, specialized in dresses and shirts brands: own label, mo851, Luisa Cevese, Monika Esser

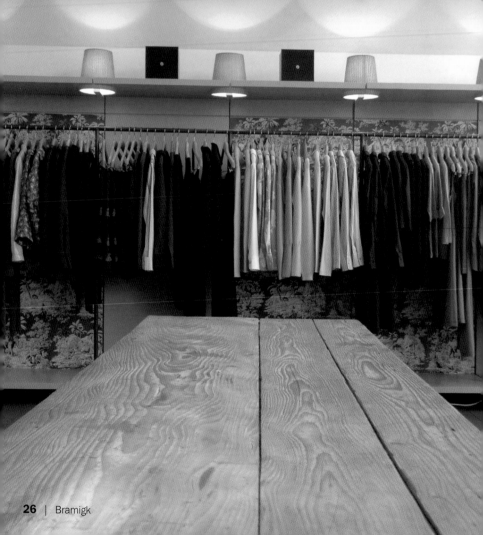

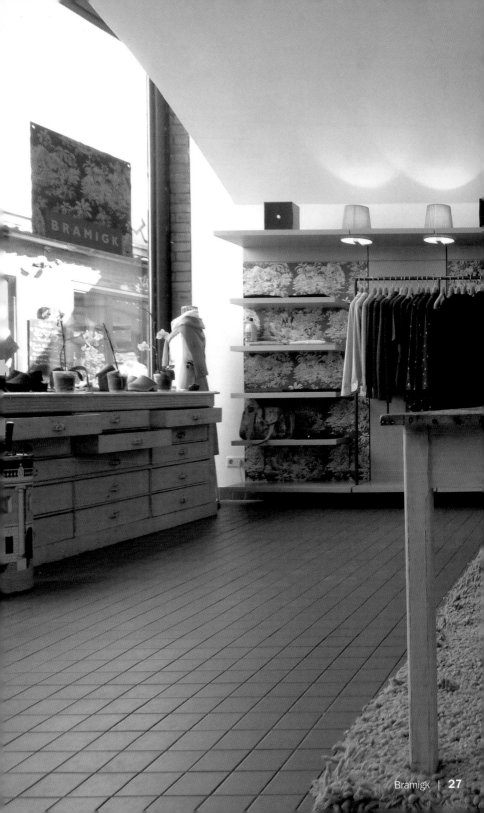

Bücherbogen
Knesebeckstraße

Design: Gerhard Spangenberg

Knesebeckstraße 27 | 10623 Berlin | Charlottenburg
Phone: +49 30 88 68 36 95
www.buecherbogen.com
Subway: Savignyplatz
Opening hours: Mon–Fri 10 am to 8 pm, Sat 10 am to 6 pm
Products: Books of art, architecture, design and photography
Special features: International selection of reduced books, presentation of book conceptions

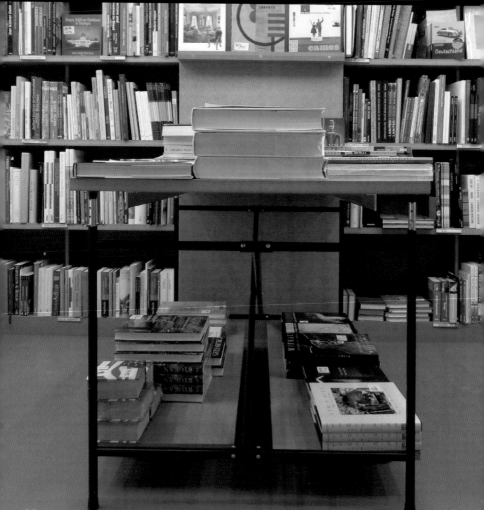

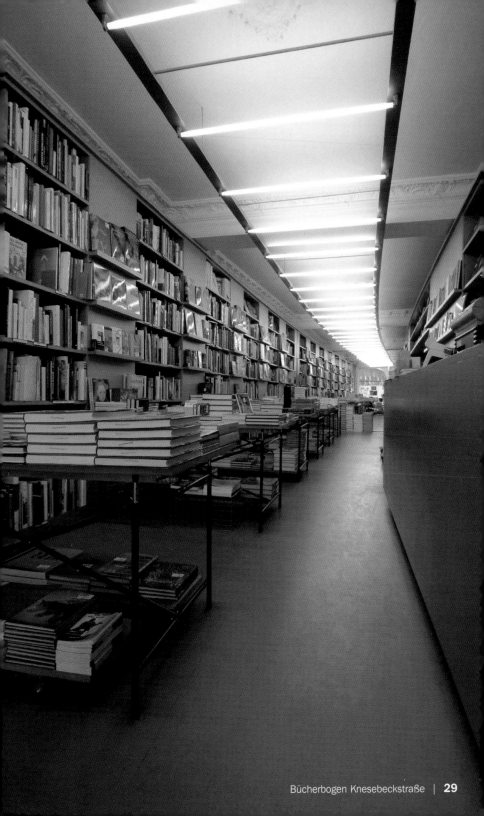

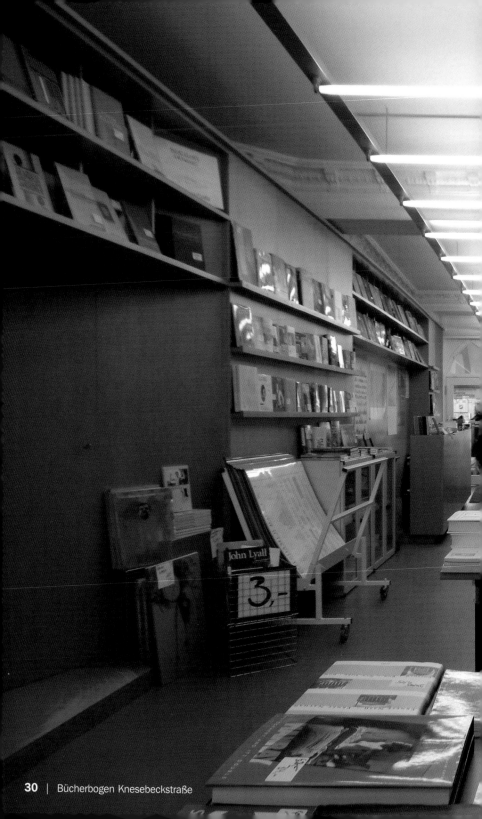

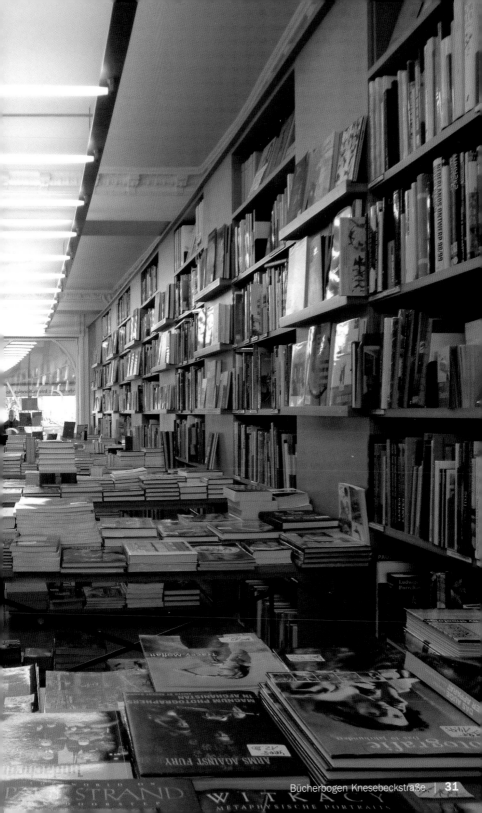

Bücherbogen

Nationalgalerie

Design: Gerhard Spangenberg

Potsdamer Straße 50 | 10785 Berlin | Tiergarten
Phone: +49 30 2 61 10 90
www.buecherbogen.com
Subway: Potsdamer Platz
Opening hours: Tue–Fri 10 am to 6 pm, Sat, Sun 11 am to 6 pm
Products: Artbooks of the 20th and 21st century architecture, international books of art and architecture in Berlin
Special features: Assorted books for individual exhibitions

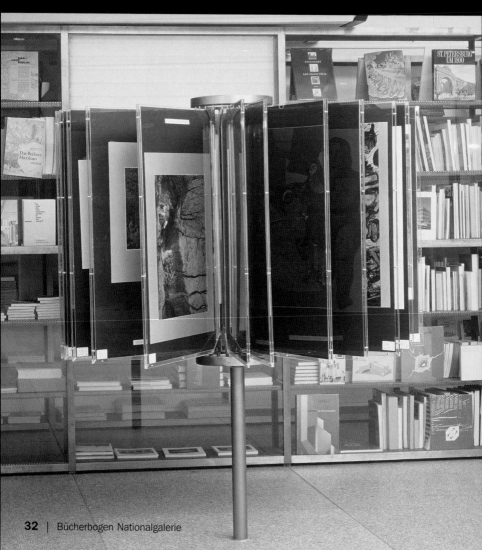

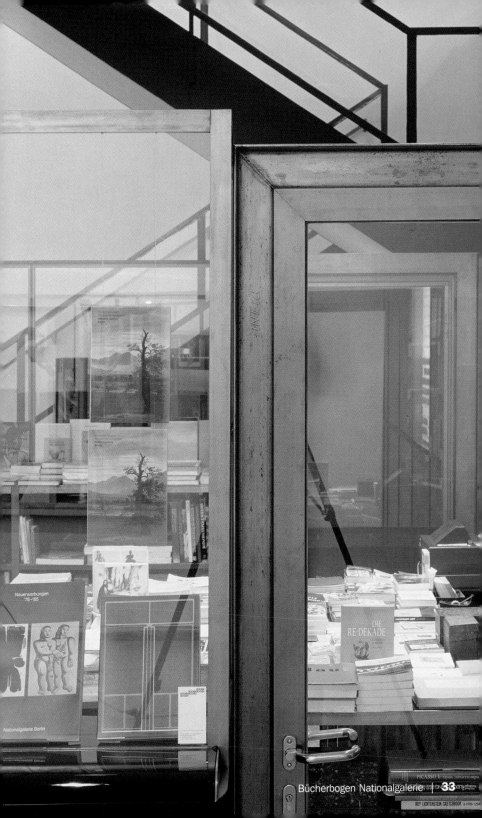

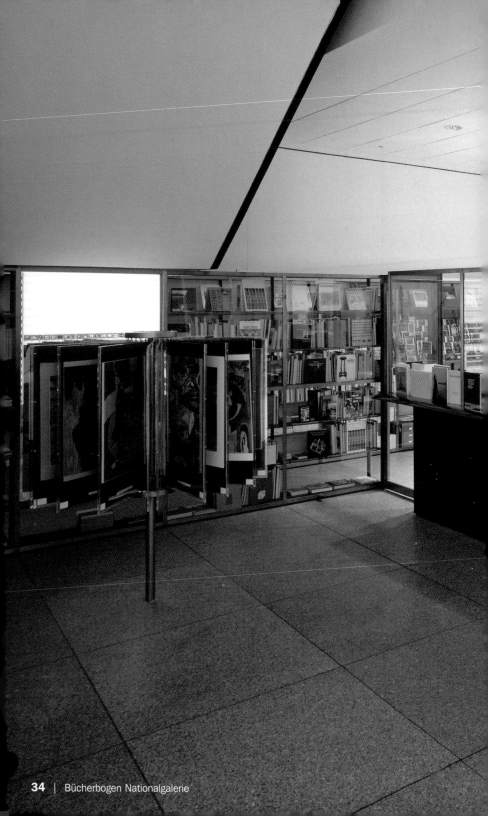

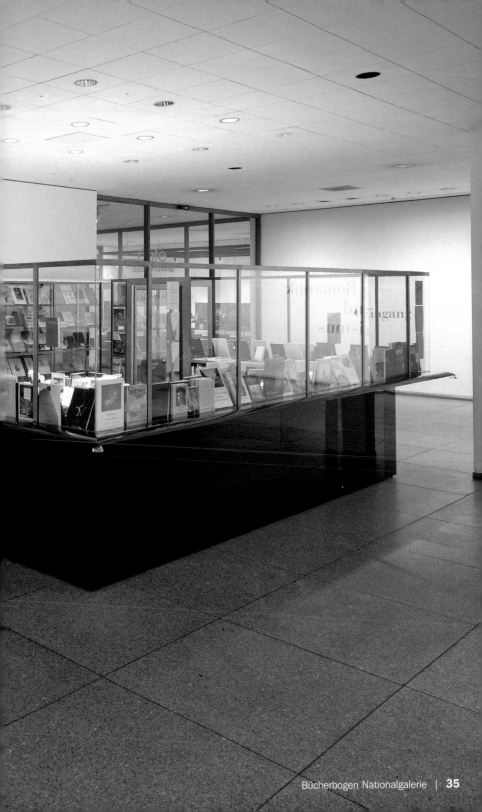

Claudia Skoda

Design: Ward Merrill Hooper

Alte Schönhauser Straße 35 | 10119 Berlin | Mitte
Phone: +49 30 2 80 72 11
www.claudiaskoda.com
Opening year: 2002
Subway: Weinmeisterstraße, Rosa-Luxemburg-Platz, Hackescher Markt
Opening hours: Mon–Fri noon to 8 pm, Sat noon to 7 pm
Products: Exclusive design knitwear for men and women

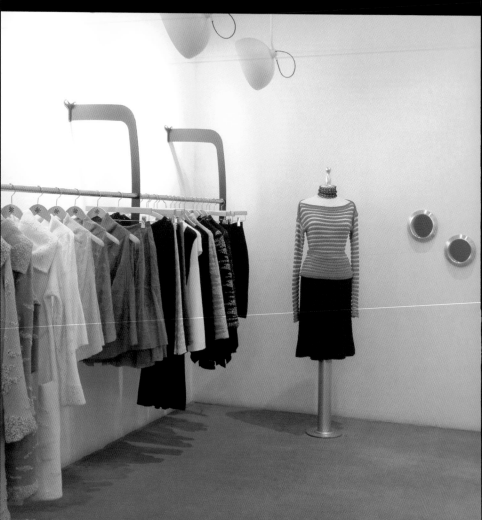

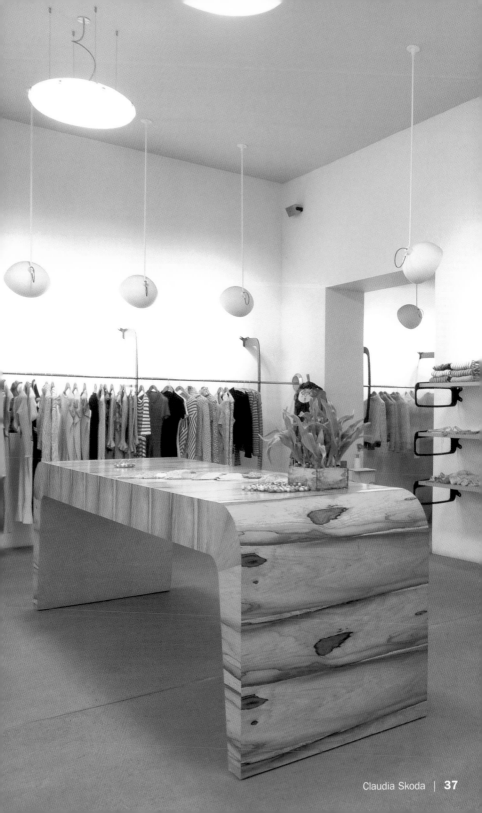

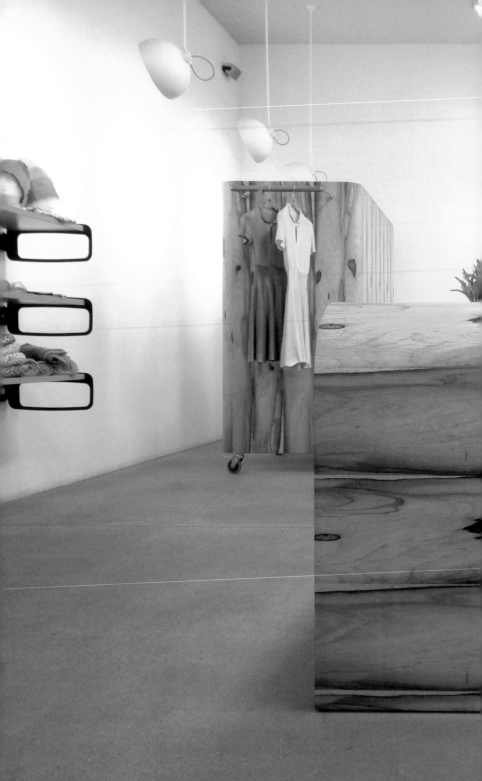

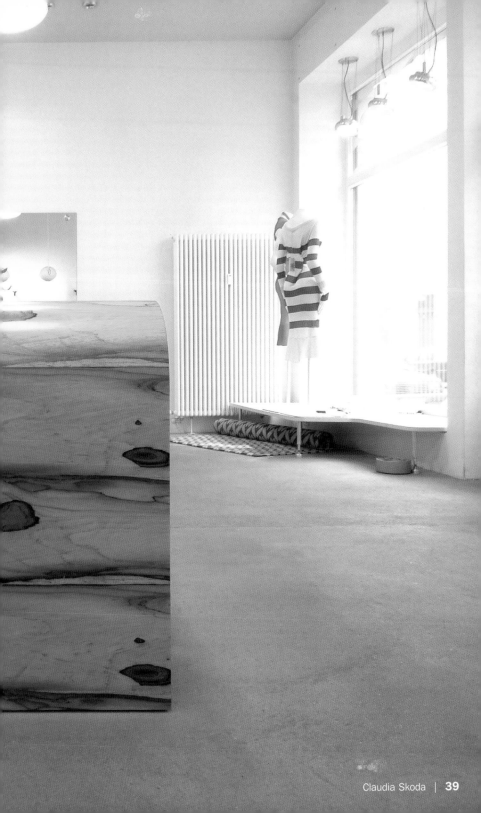

Claudia Skoda | **39**

dazu

Design: Helena Ahonen, Lui Gerdes

Kopernikusstraße 14 | 10245 Berlin | Friedrichshain
Phone: +49 30 53 21 11 44, +49 30 29 66 75 31
www.helenaahonen.com | www.ichichich-berlin.de
Opening year: 2002
Subway: Warschauer Straße
Opening hours: Thu–Fri 4 pm to 8 pm, Sat noon to 4 pm, or call for appointment
Products: Exclusive and handmade hats and bags

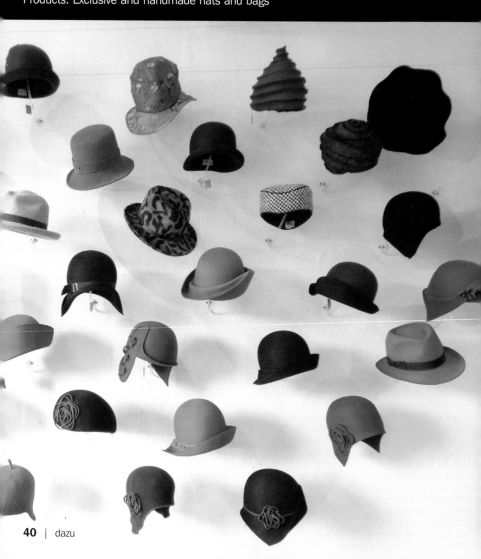

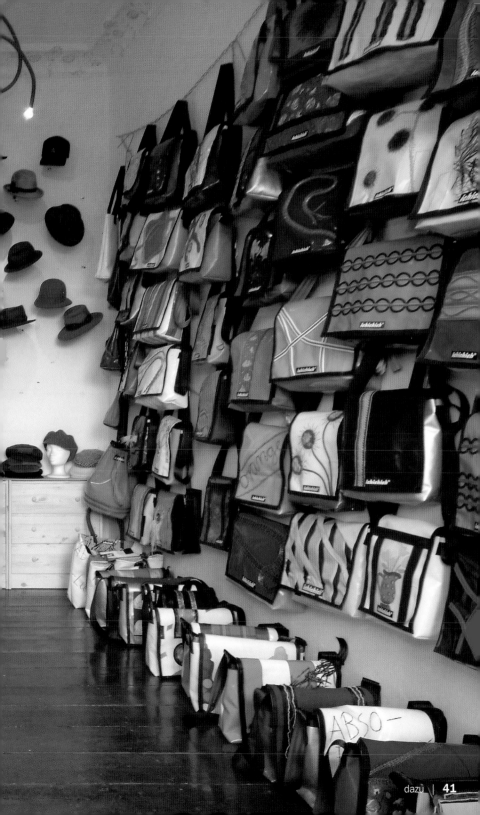

dopo domani

Design: Arno Schneider

Kantstraße 148 | 10623 Berlin | Charlottenburg
Phone: +49 30 8 82 22 42
www.dopo-domani.com
Opening year: 1986
Subway: Savignyplatz
Opening hours: Mon–Fri 10:30 am to 7 pm, Sat 10 am to 6 pm
Products: Furniture, accessories, illumination
Special features: Consultation, planning, realization

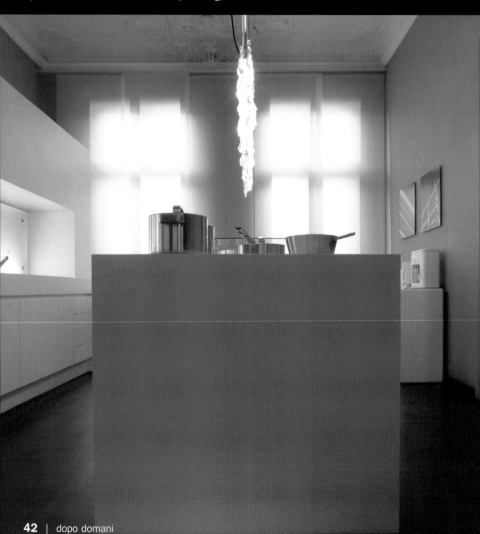

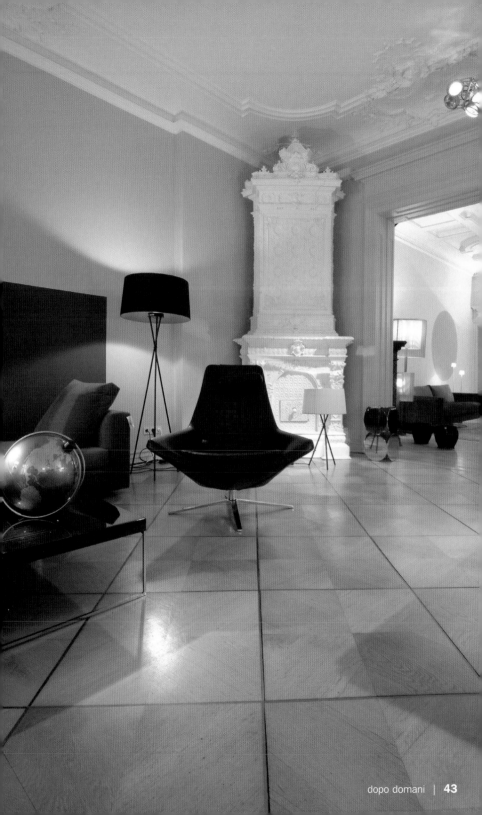

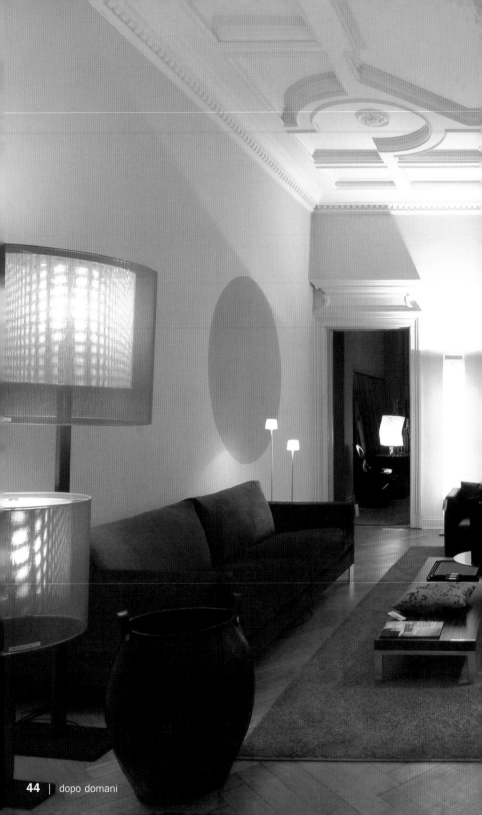

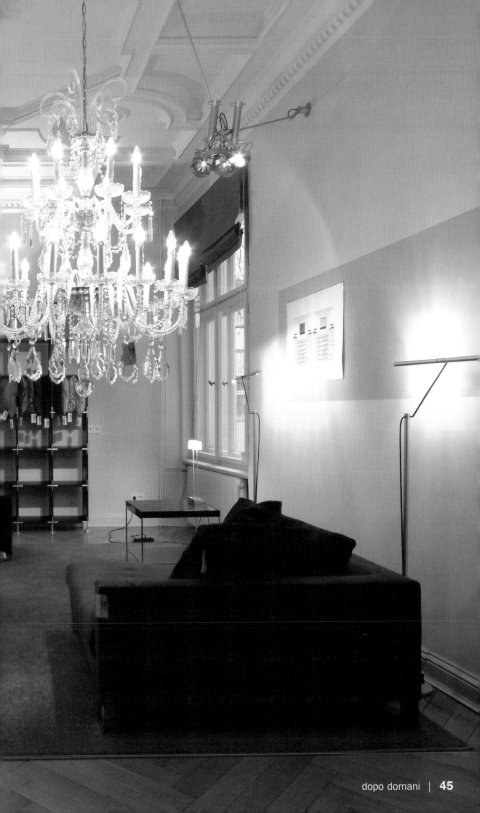

Dussmann das KulturKaufhaus

Design: Kreft Brübach GmbH

Friedrichstraße 90 | 10117 Berlin | Mitte
Phone: +49 30 20 25 11 11
www.kulturkaufhaus.de
Subway: Friedrichstraße
Opening hours: Mon–Sat 10 am to 10 pm
Products: Books, CD's (classic, pop, jazz, worldmusic), DVD's, VHS, software,
music notes, fine papers, gifts
Special features: Catherine's café and restaurant, 10–15 events every month, listening
counters, reading galleries, renting of reading glasses and CD-players

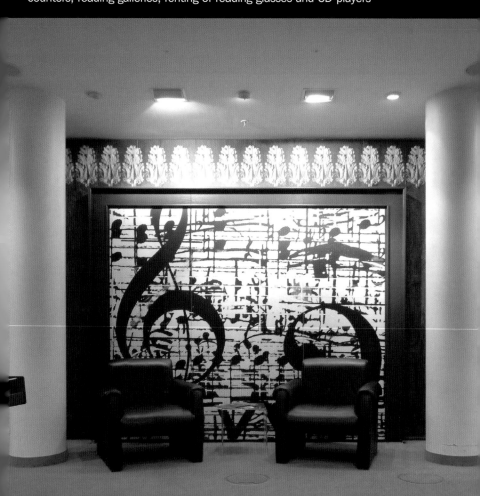

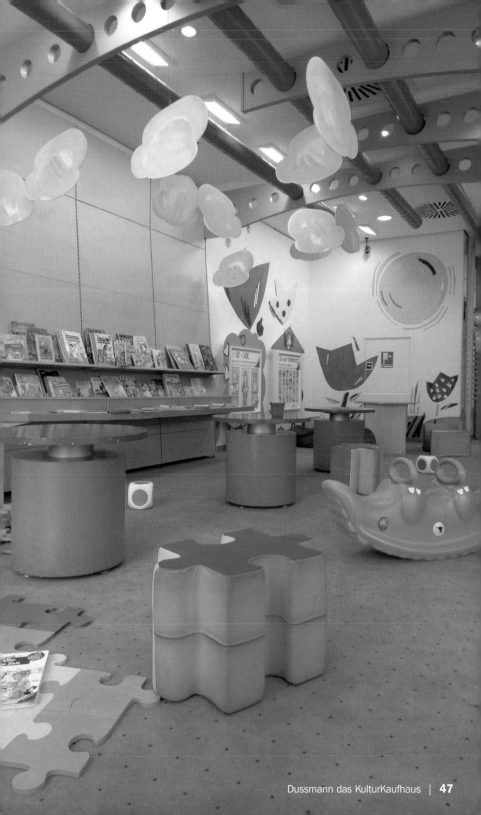

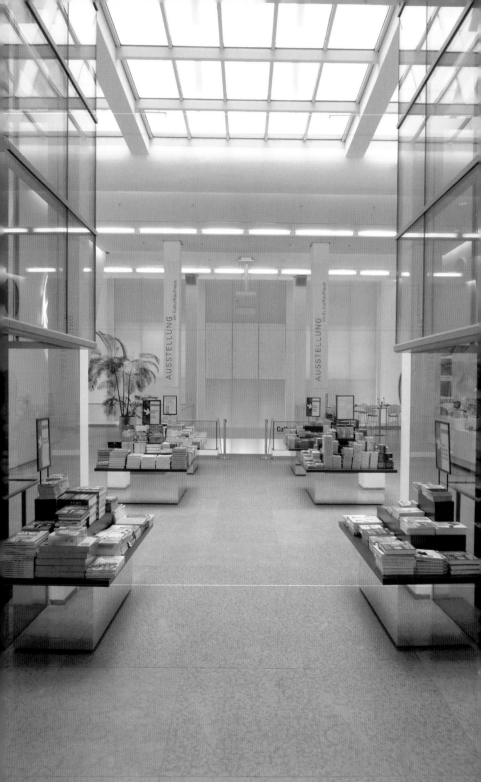

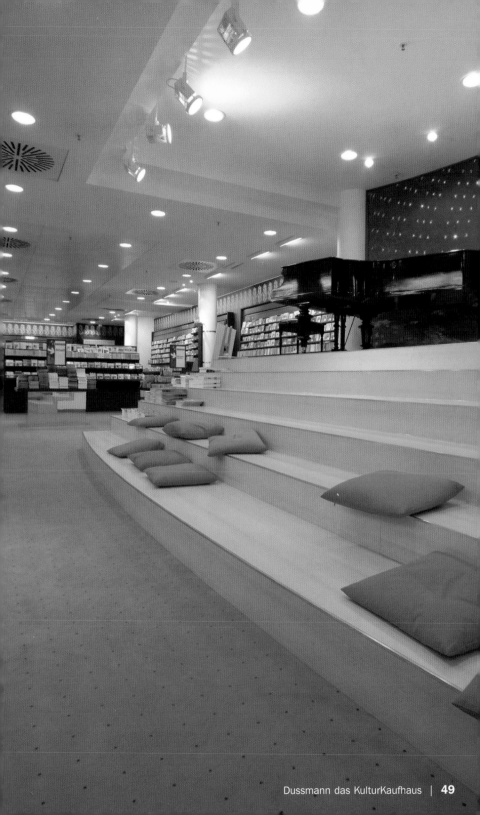

Fiona Bennett

Design: Fiona Bennett

Große Hamburger Straße 25 | 10115 Berlin | Mitte
Phone: +49 30 28 09 63 30
www.fionabennett.com
Opening year: 1999
Subway: Hackescher Markt, Weinmeisterstraße
Opening hours: Mon–Fri 10 am to 6 pm, Sat noon to 6 pm, or call for appointment
Products: Women and men designer hats for day and evening
Special features: Unique designer headgear, handmade, glamorous shop interieur in lilac and red

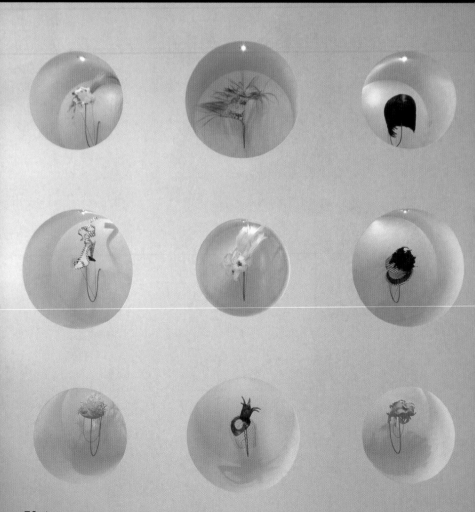

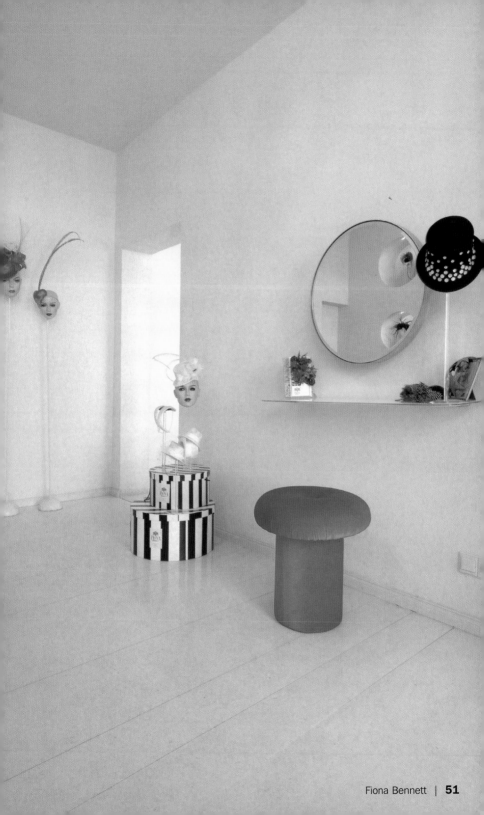

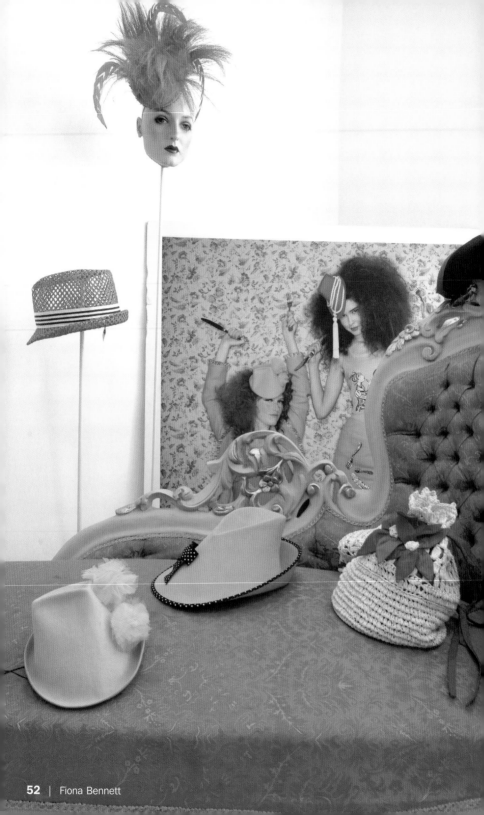

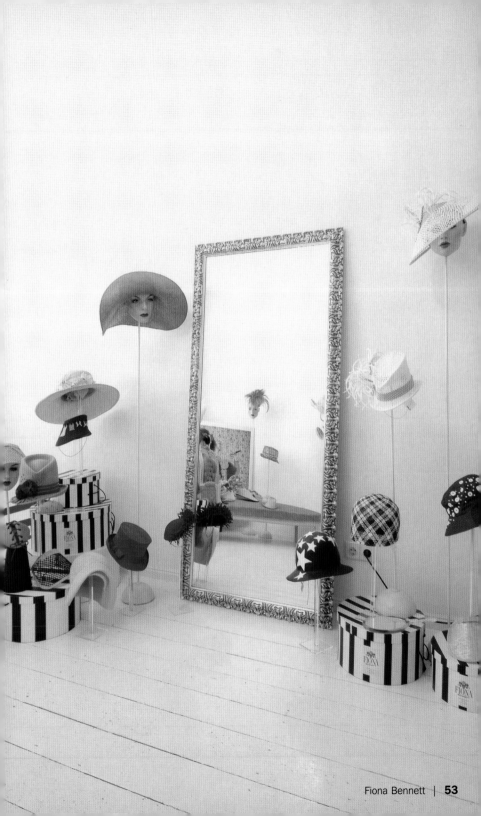

gut und schön

Design: Ralf Pfeiffer

Torstraße 140 | 10119 Berlin | Mitte
Phone: +49 30 28 88 45 75
www.gutundschoen.com
Opening year: 2003
Subway: Rosenthaler Platz
Opening hours: Mon–Fri 10 am to 7 pm, Sat 11 am to 6 pm
Products: Furniture, living accessories, architecture, interior design
Special features: Lectures by architects and designers, consultation, planning, realization

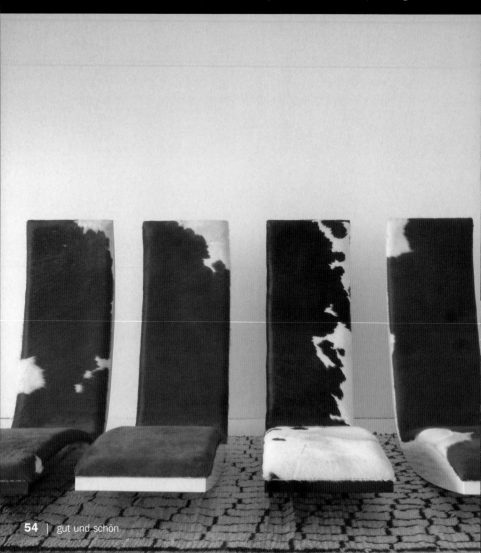

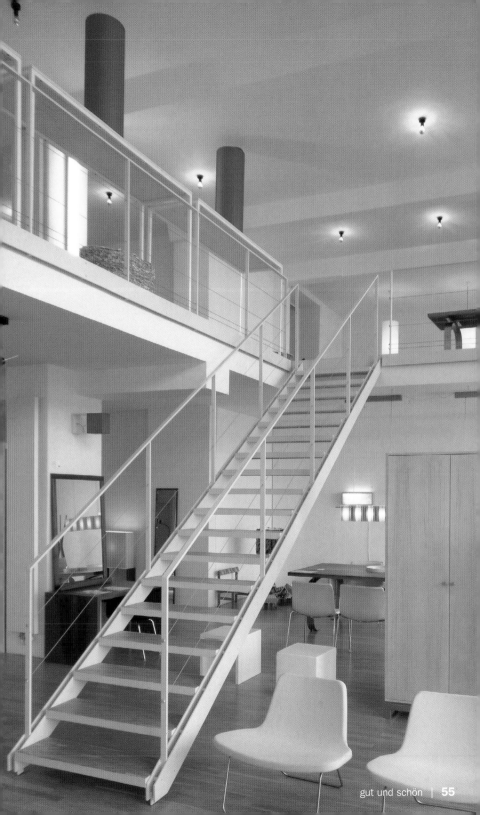

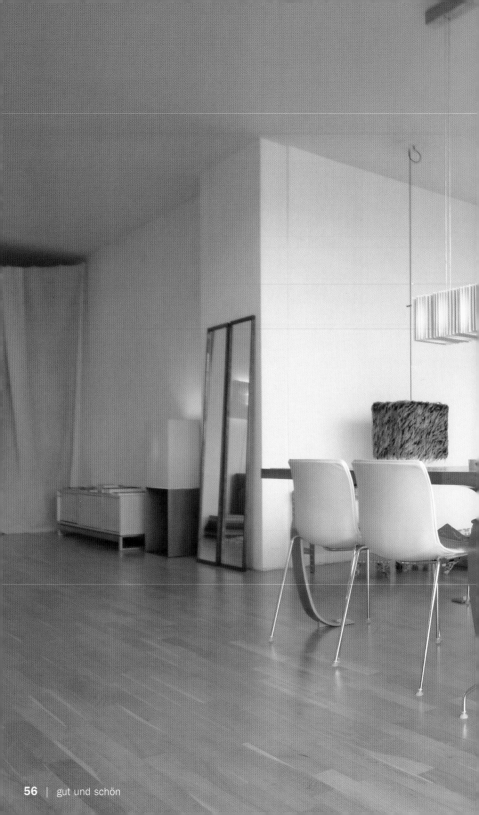

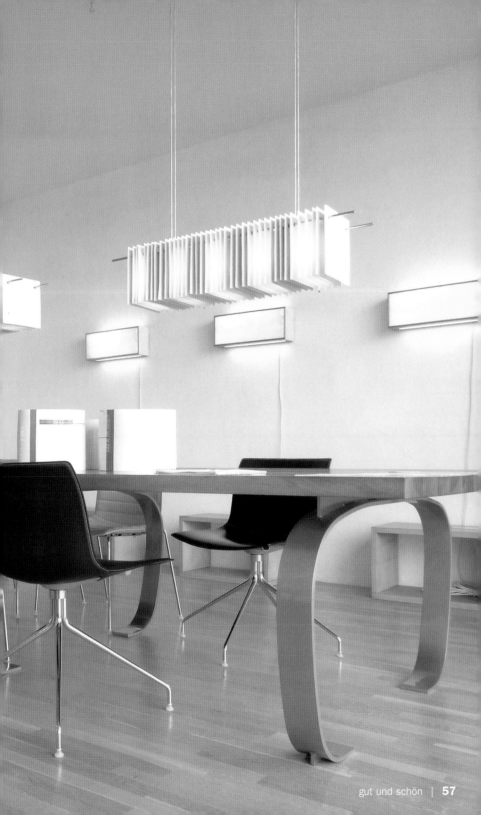

Hut Up Berlin

Design: Christine Birkle

Heckmannhöfe, Oranienburger Straße 32 | 10117 Berlin | Mitte
Phone: +49 30 28 38 61 05
www.hutup.de
Opening year: 1998
Subway: Oranienburger Straße
Opening hours: Mon–Sat 11 am to 7 pm
Products: Exclusive handmade clothes, accessories, home products, baby- and wedding collections, made of extra fine merino wool and delicate fabrics

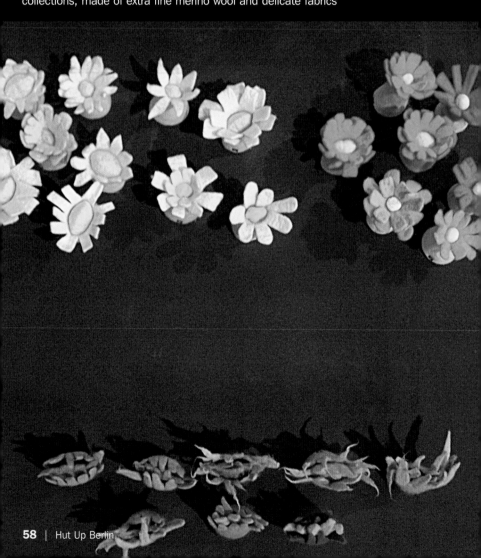

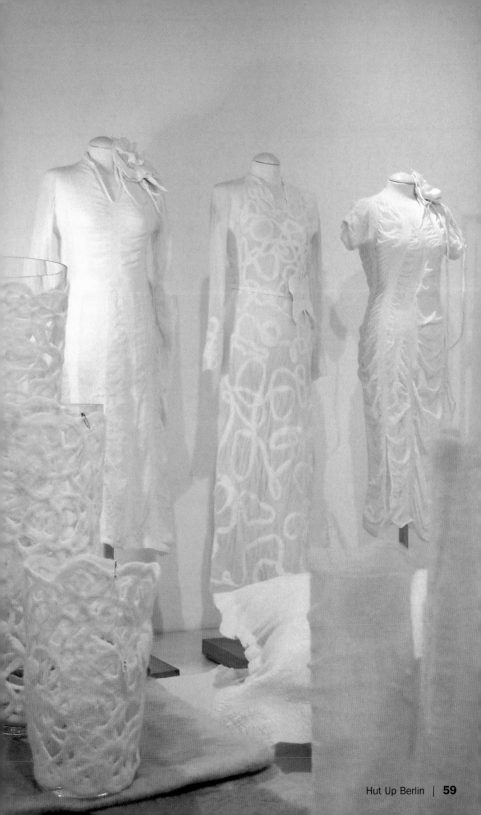

in't Veld Schokoladen

Design: kumpanin+

Dunckerstraße 10 | 10437 Berlin | Prenzlauer Berg
Phone: +49 30 48 62 34 23
www.intveld.de
Subway: Eberswalder Straße
Opening hours: Mon–Fri noon to 7 pm, Sat 11 am to 6 pm
Products: Best chocolate
Special features: Unique selection of the most intense worldwide cocoa-products, own
brand including chili and solt-chocolate, many pure 100% cocoa products, a café next
door serving chocolate drinks and specialized chocolate treats

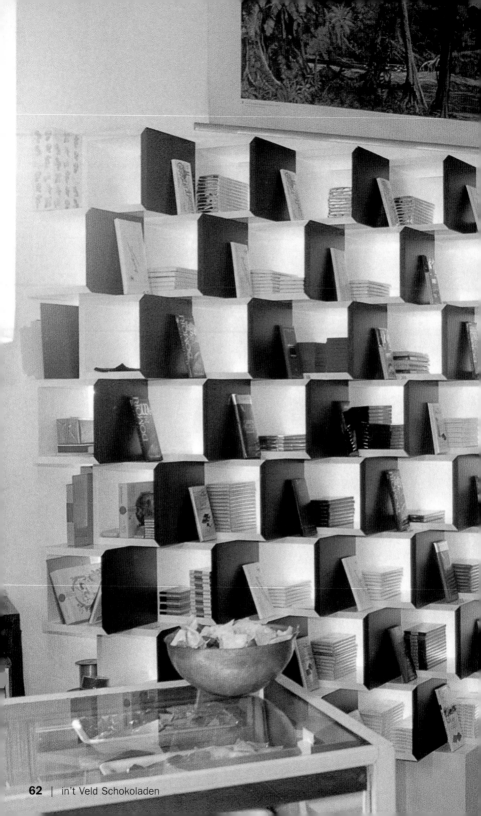

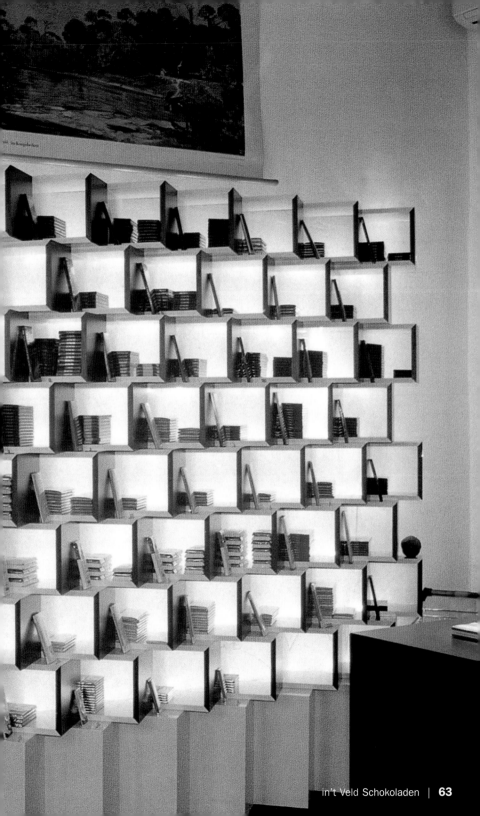

I Pinco Pallino

Design: Imelde and Stefano Cavalleri

Kurfürstendamm 46 | 10707 Berlin | Charlottenburg
Phone: +49 30 8 81 28 63
www.ipincopallino.it
Opening year: 2004
Subway: Savignyplatz, Kurfürstendamm
Opening hours: Mon–Fri 10 am to 7 pm, Sat 10 am to 6 pm
Products: I Pinco Pallino, I Pinco Pallino baby, 1950 clothes, shoes and accessories

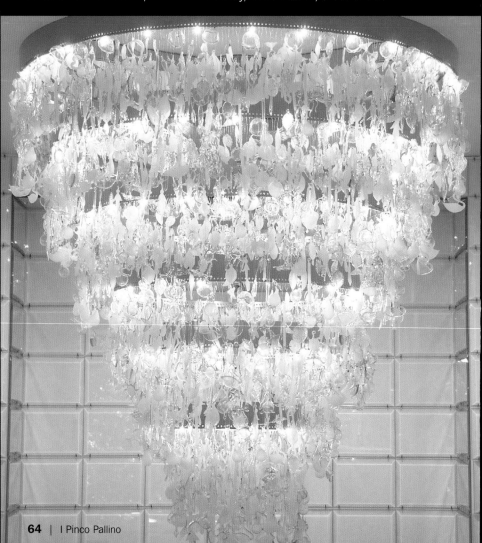

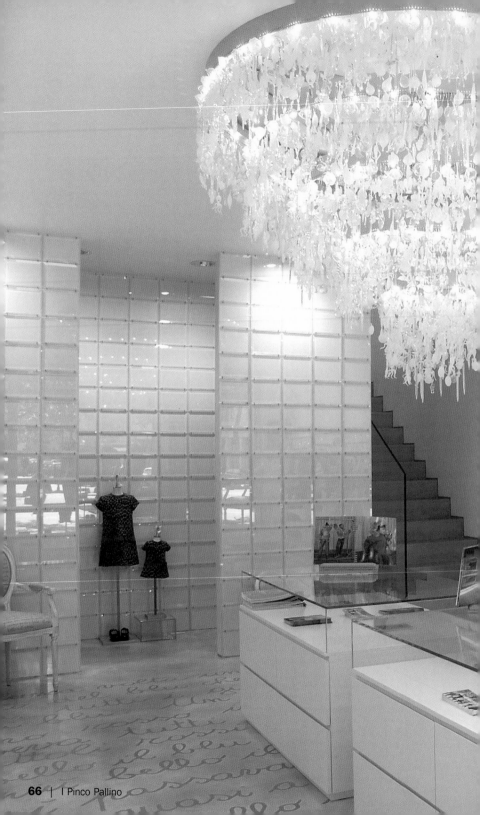

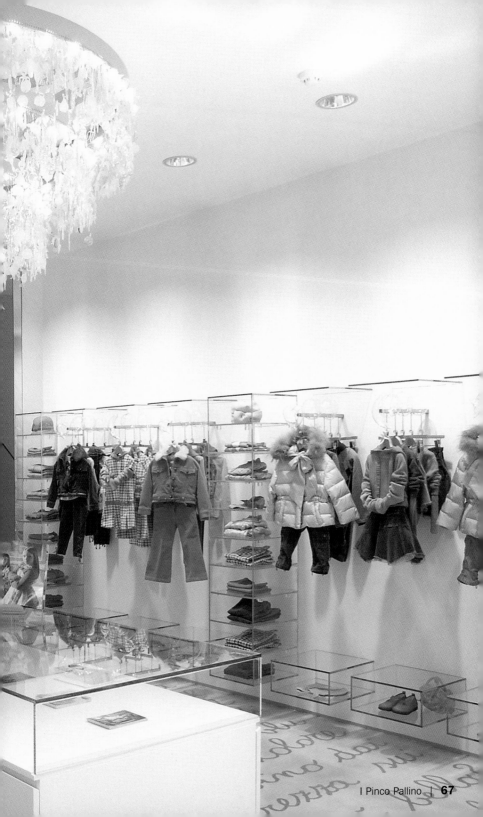

ITO. The Berlin Shop

Design: Yoshiharu Ito

Auguststraße 19 | 10117 Berlin | Mitte
Phone: +49 30 44 04 44 90
www.itofashion.com
Opening year: 2000
Subway: Oranienburger Straße, Oranienburger Tor, Weinmeisterstraße
Opening hours: Mon–Sat noon to 8 pm
Products: Women and men collection designed by Yoshiharu Ito in limited editions, accessories, shoes, bags, belts in limited editions
Special features: Brunchparties for new collection presentations

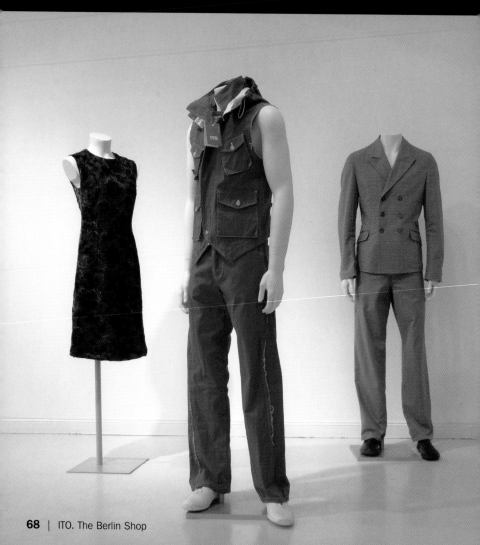

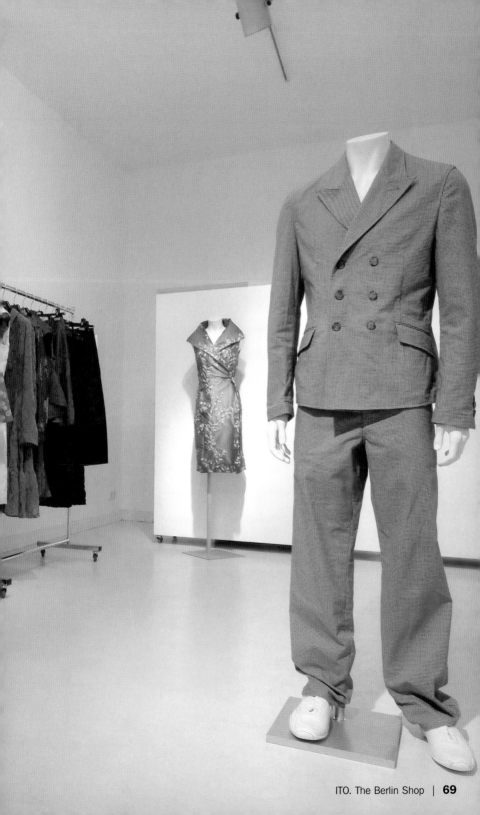

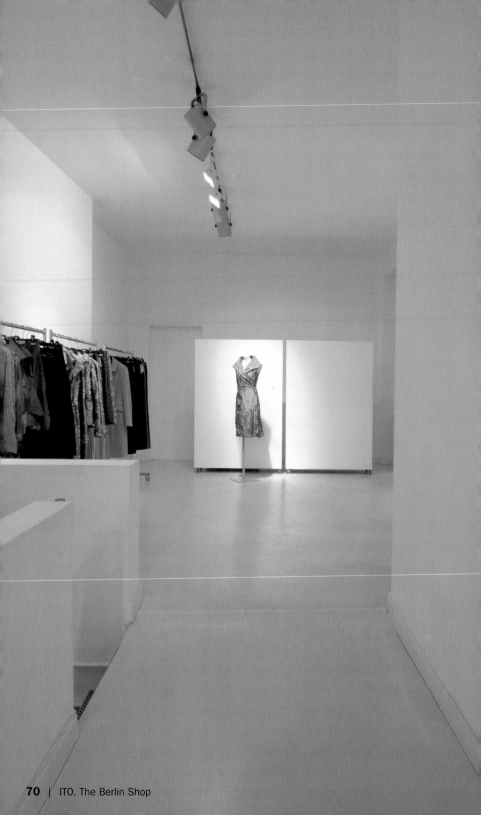

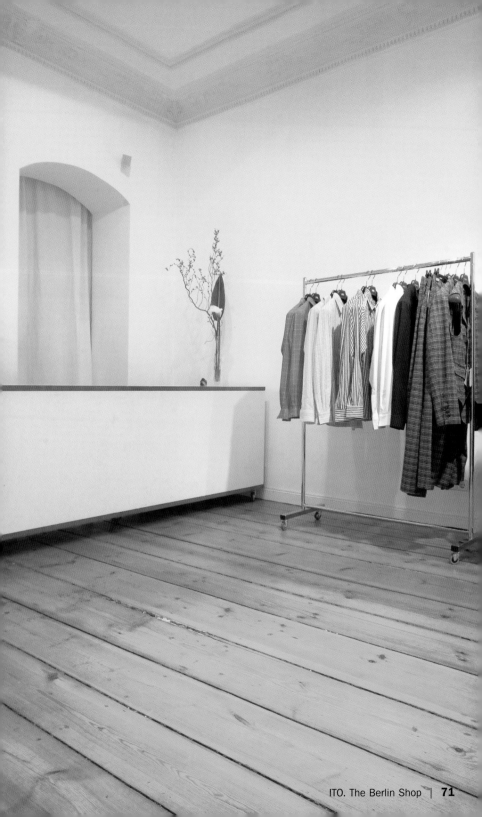

Lisa D.

Design: Christian Aulinger, Dagmar Niecke, Marinus van Eldik

Hackesche Höfe, Rosenthaler Straße 40–41 | 10178 Berlin | Mitte
Phone: +49 30 2 82 90 61
www.lisad.com
Opening year: 1995
Subway: Hackescher Markt, Weinmeisterstraße
Opening hours: Mon–Sat 11 am to 7:30 pm
Products: Women's fashion

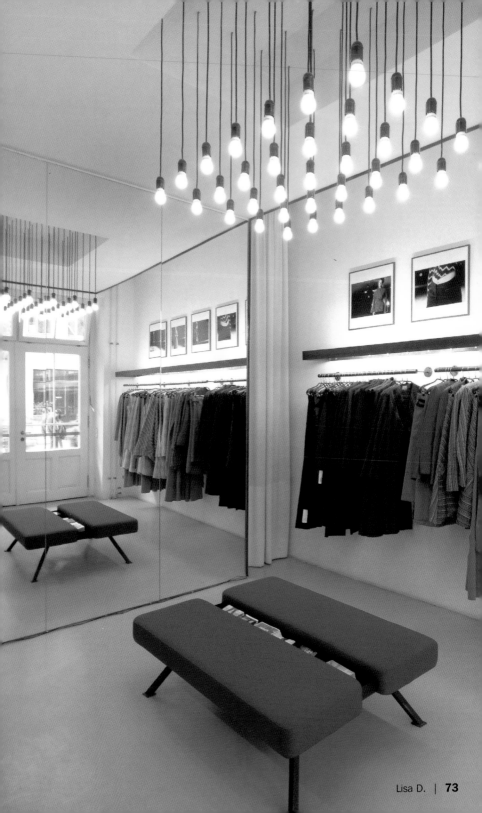

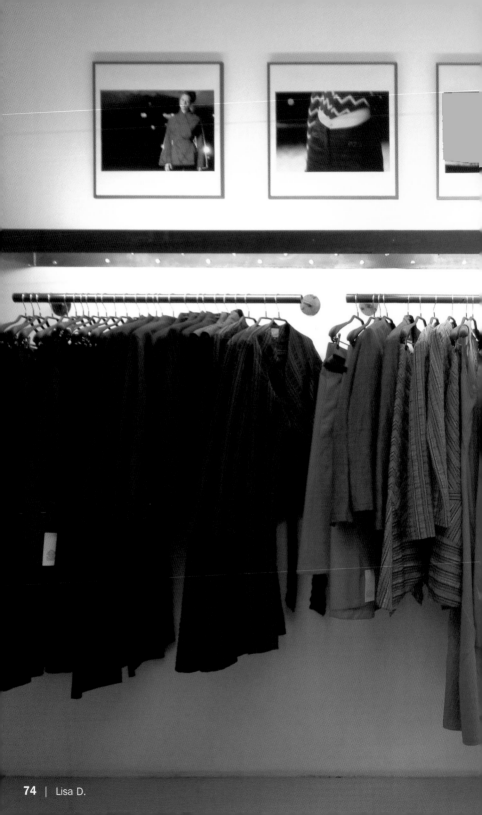

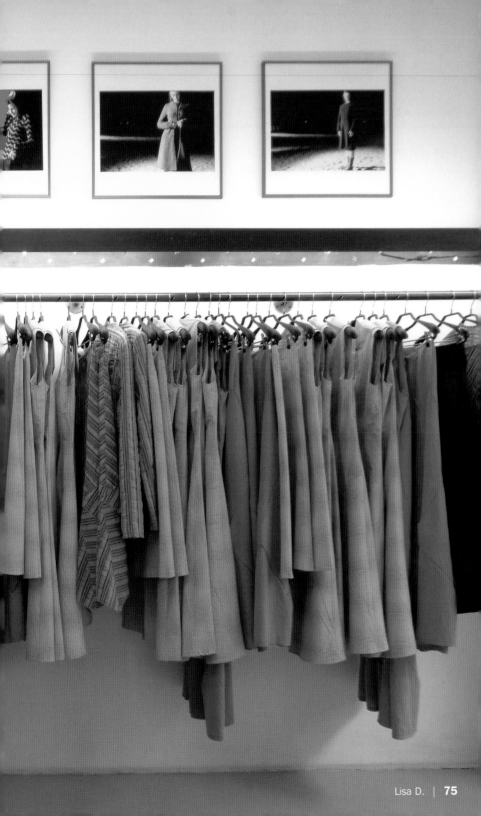

lucid21

Design: Sylvia Kranawetvogl, Luis Gunsch

Mariannenstraße 50 | 10997 Berlin | Kreuzberg
Phone: +49 30 62 98 16 52
www.lucid21.net
Opening year: 2002
Subway: Görlitzer Bahnhof, Kottbusser Tor
Opening hours: Tue–Fri noon to 7 pm, Sat noon to 4 pm
Products: Women's fashion, jewelry, accessories
Special features: Shop with own collection by Sylvia Kranawetvogl and Luis Gunsch

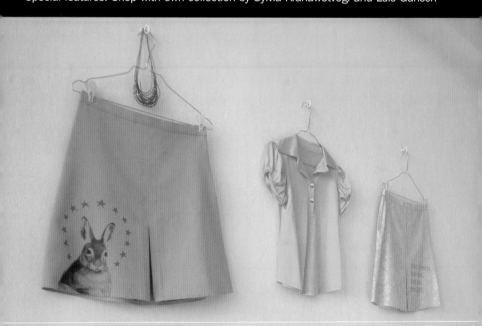

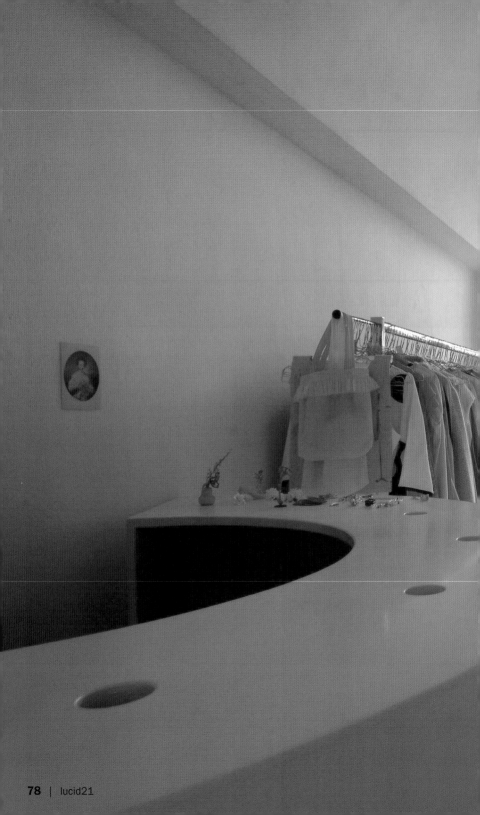

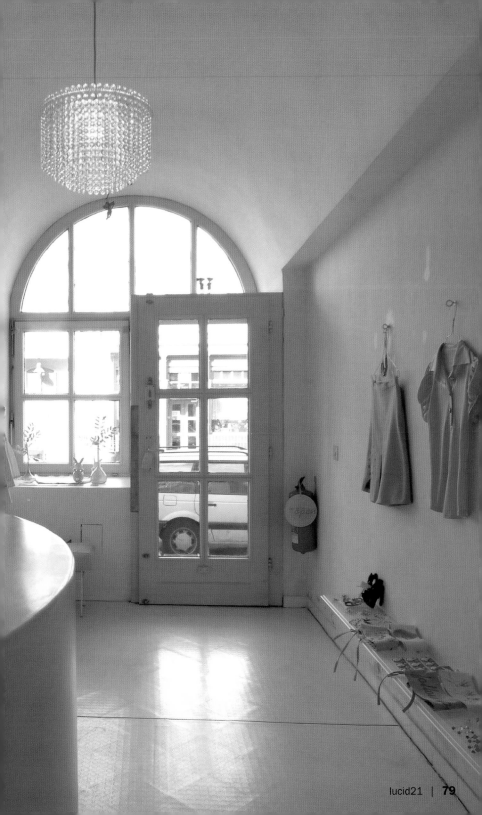

Mane Lange

Design: Mane Lange

Hagenauer Straße 13 | 10435 Berlin | Prenzlauer Berg
Phone: +49 30 44 32 84 82
www.manelange.de
Opening year: 2001
Subway: Eberswalder Straße
Opening hours: Please call for appointment
Products: Measure-manufactured corsets, bridal and evening couture collection
Special features: Individual consultation

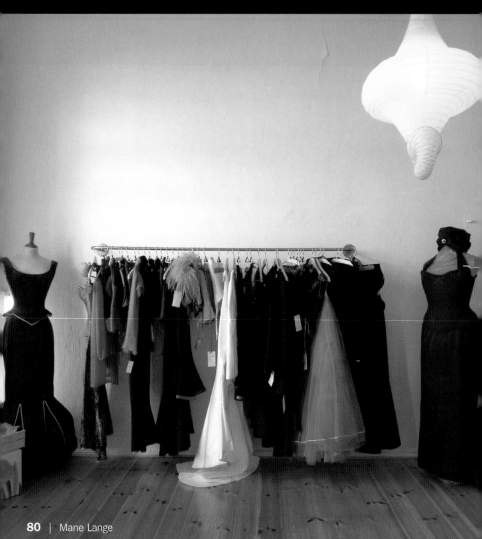

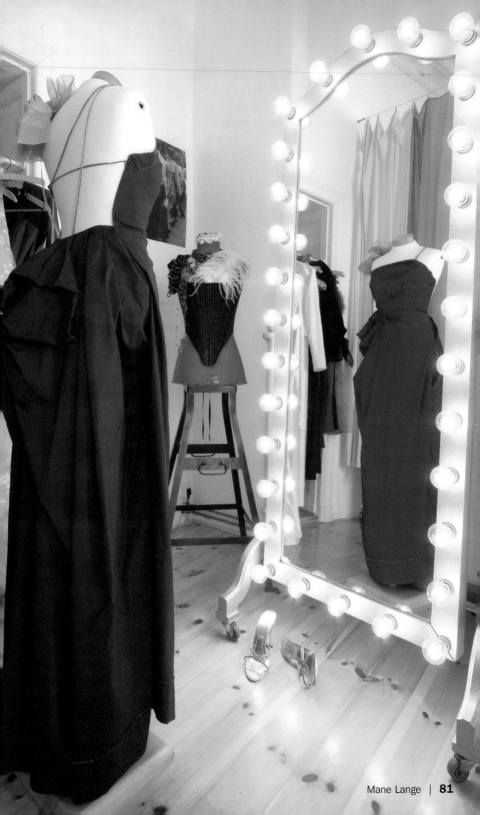

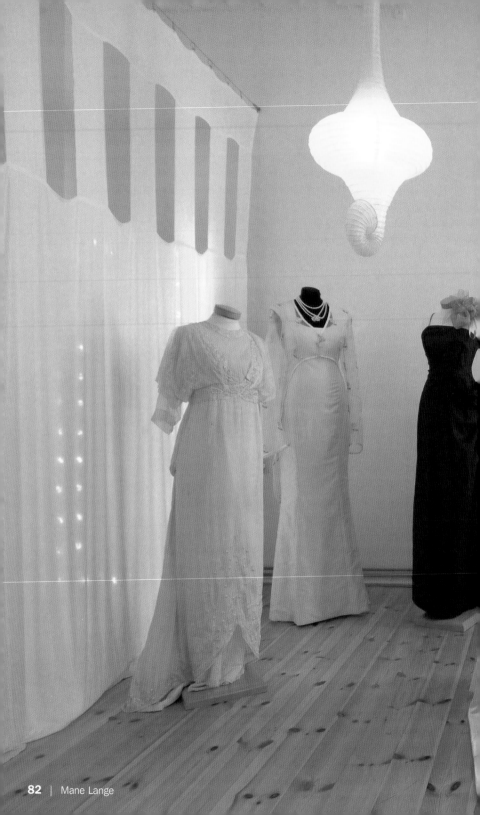

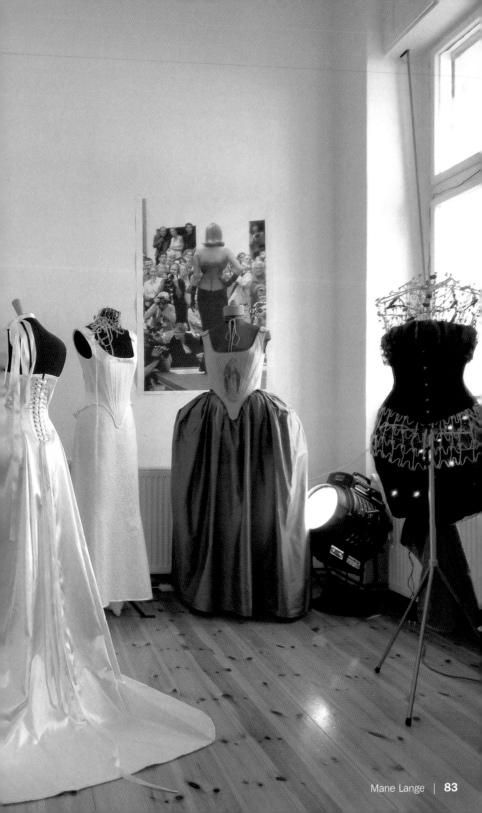

Modeagentur Klauser

Design: Lanzi Selezioni

Wallstraße 16 | 10179 Berlin | Mitte
Phone: +49 30 4 70 36 00
www.modeagentur-klauser.de
Opening year: 2004
Subway: Spittelmarkt
Opening hours: Mon–Fri 9 am to 6 pm
Products: Fashion, wholesale

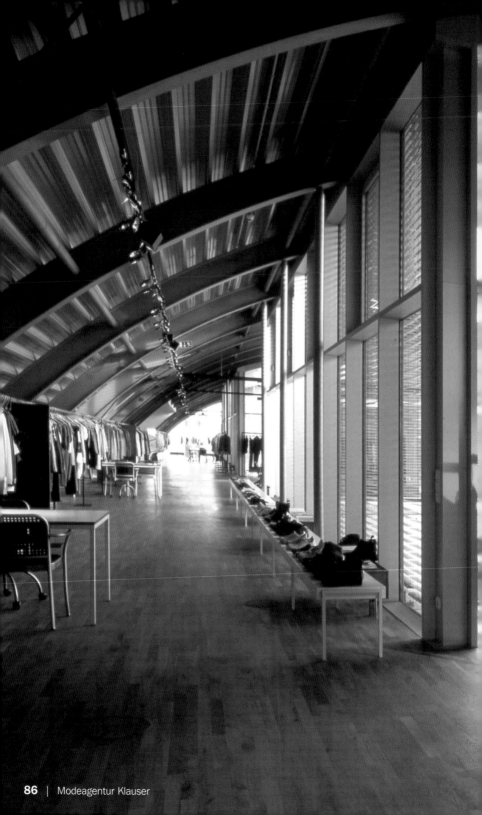

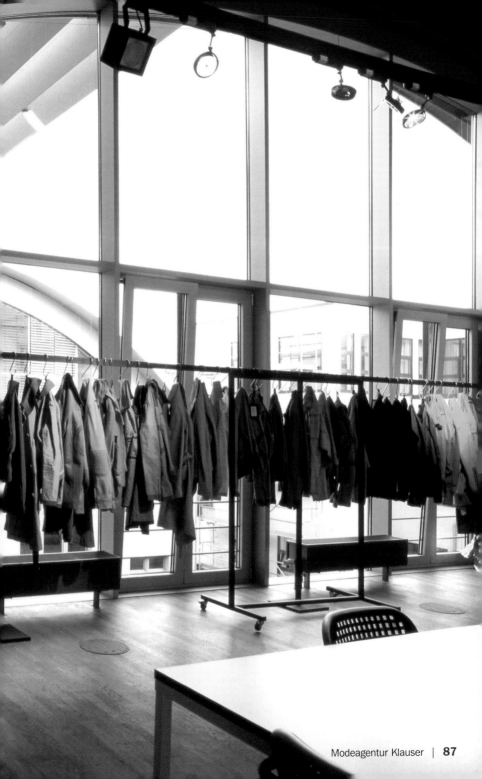

Nanna Kuckuck –Haute Couture

Design: Susanne Gerlinger

Bleibtreustraße 52 | 10623 Berlin | Charlottenburg
Phone: +49 30 31 50 71 50
www.nanna-kuckuck.de
Opening year: 1996
Subway: Savignyplatz
Opening hours: Mon only with appointment, Tue–Fri noon to 7 pm, Sat noon to 4 pm
Products: Haute couture, glamorous dresses, 1001-night robes
Special features: Individual consultation

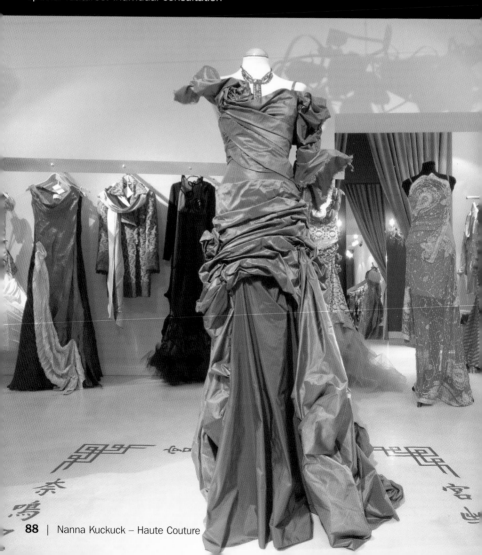

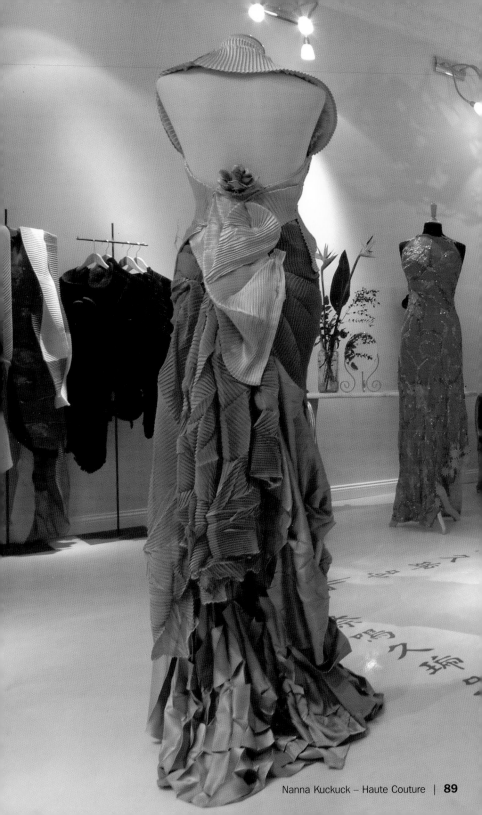

NIX

Design: Michael Heim Architekt

Heckmannhöfe, Oranienburger Straße 32 | 10117 Berlin | Mitte
Phone: +49 30 2 81 80 44
www.nix.de | www.PAPP-berlin.de
Opening year: 2004
Subway: Oranienburger Straße, Oranienburger Tor
Opening hours: Mon–Sat 11 am to 8 pm
Products: Fashion, kid's fashion, accessories, jewelry
Special features: Café, exhibitions

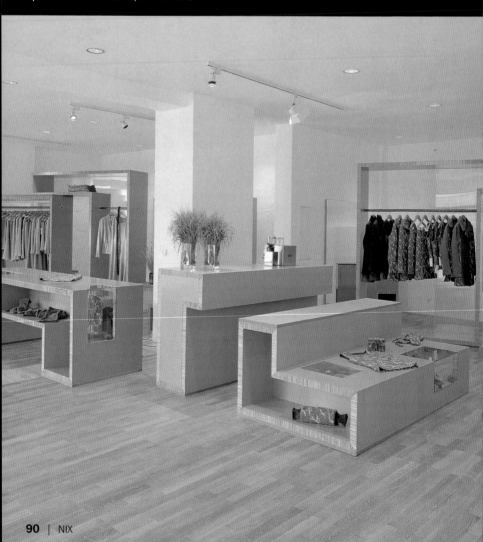

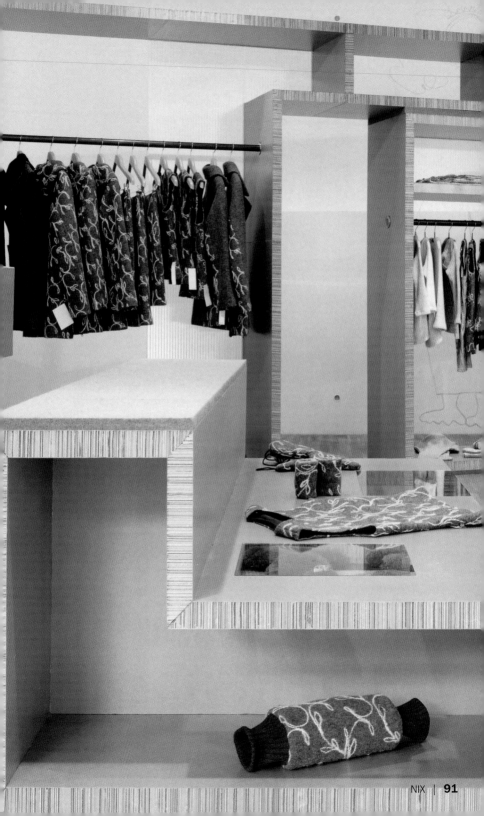

Porsche Design Store

Design: Matteo Thun

Kurfürstendamm 190–192 | 10707 Berlin | Charlottenburg
Phone: +49 30 88 71 78 30
www.porsche-design.com
Opening year: 2004
Subway: Savignyplatz, Bleibtreustraße
Opening hours: Mon–Fri 10 am to 7 pm, Sat 10 am to 6 pm
Products: Classical men's accessories; timepieces, eyewear, luggage, leather goods, writing tools, smoking accessories, shoes, pocket knives

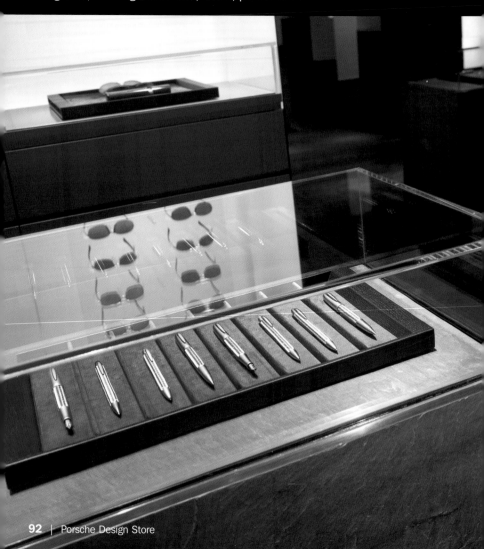

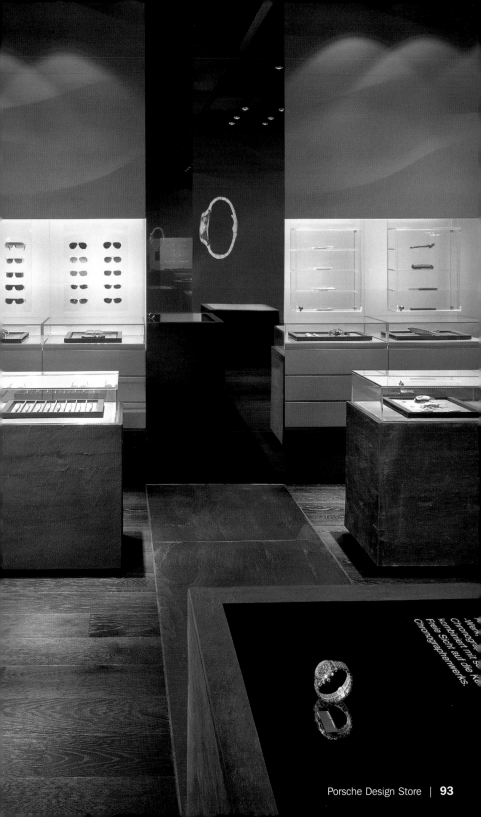

Wen

Chronograf mit

kombiniert mit die Ke

Freie Sicht auf die

Chronographenwerks.

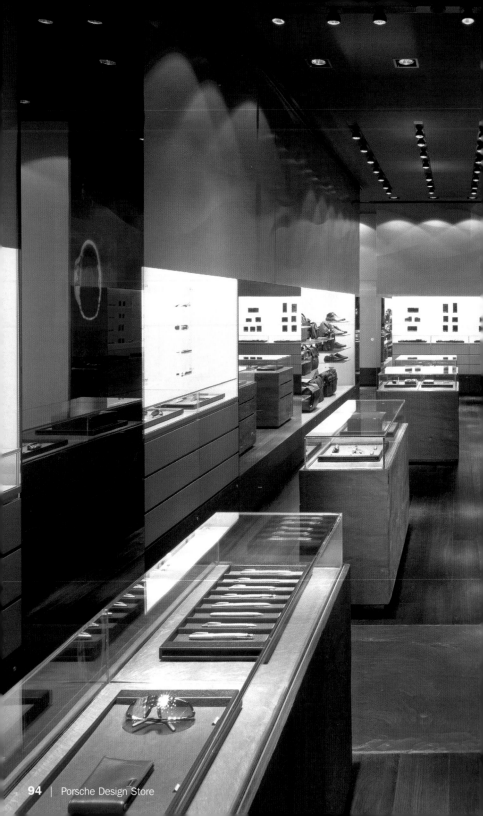

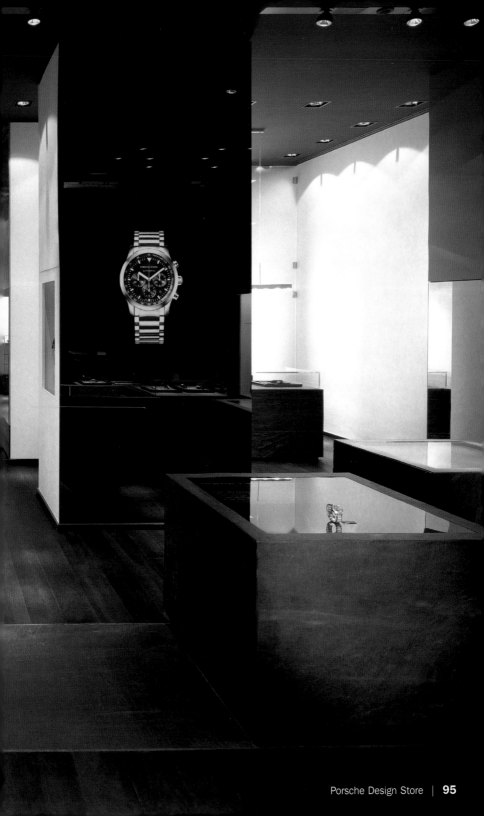

Quartier 206

Design: Pei Cobb Freed & Partners

Friedrichstraße 71 | 10117 Berlin | Mitte
Phone: +49 30 4 90 04 01
www.quartier206.com
Opening year: 1996
Subway: Französische Straße, Stadtmitte
Opening hours: Mon–Sun 10 am to 10 pm
Products: International shops, café and restaurant

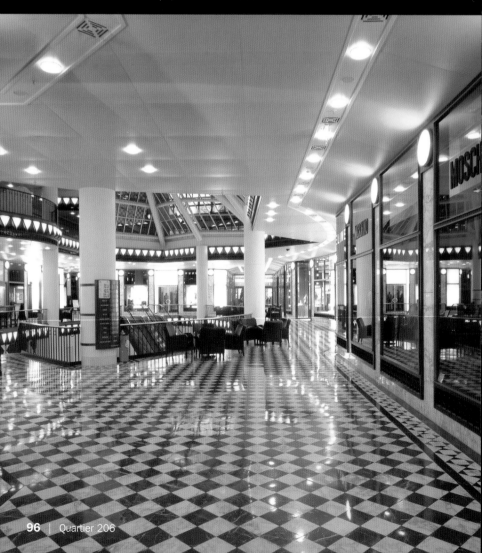

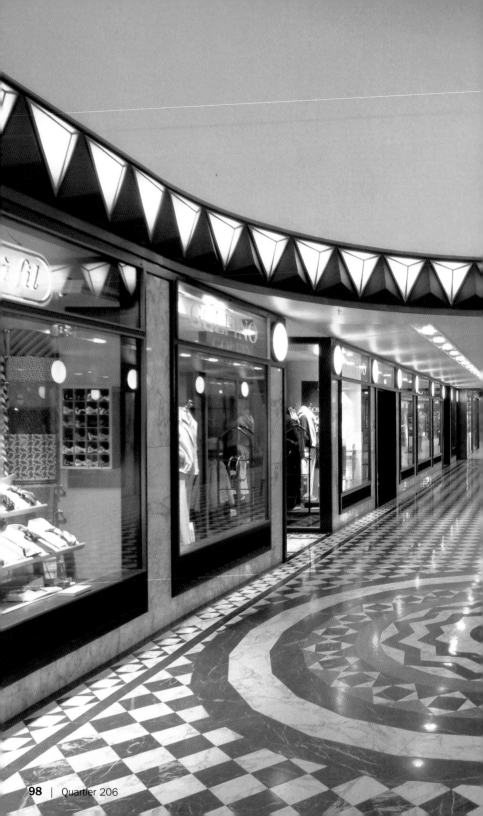

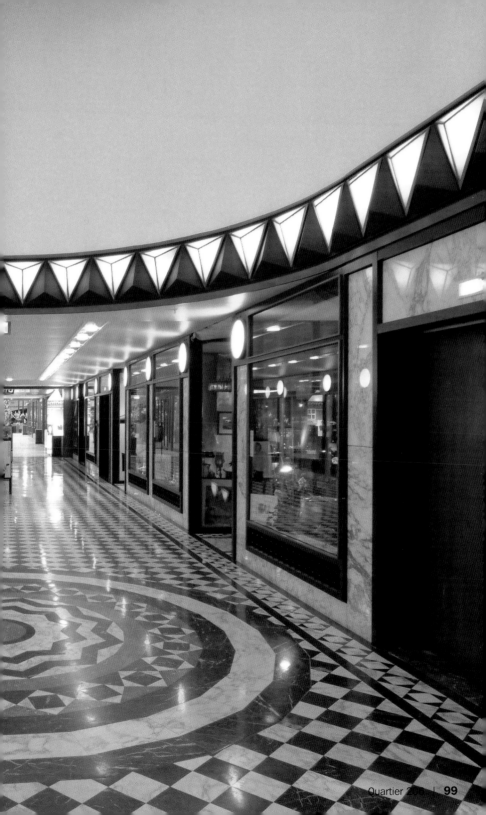

R.S.V.P

Design: Stephan Sell

Mulackstraße 14 | 10119 Berlin | Mitte
Phone: +49 30 28 09 46 44
www.rsvp-berlin.de
Opening year: 2001
Subway: Rosa-Luxemburg-Platz, Weinmeisterstraße
Opening hours: Tue–Fri noon to 7 pm, Sat noon to 4 pm
Products: Paper goods, note books, pins from all over the world, mainly from Japan, USA, England, France, Italy, Greece
Special features: All products also available online under www.rsvp-berlin.de

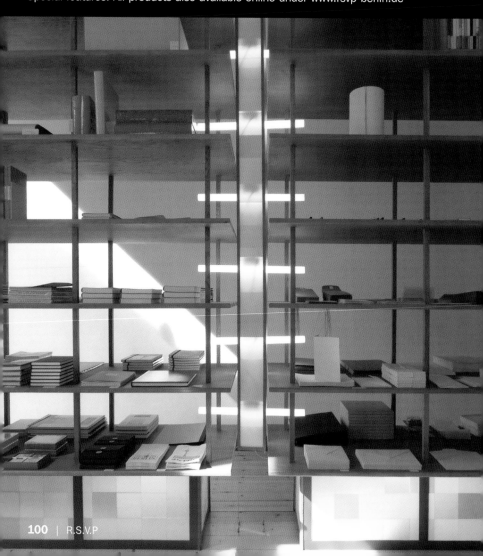

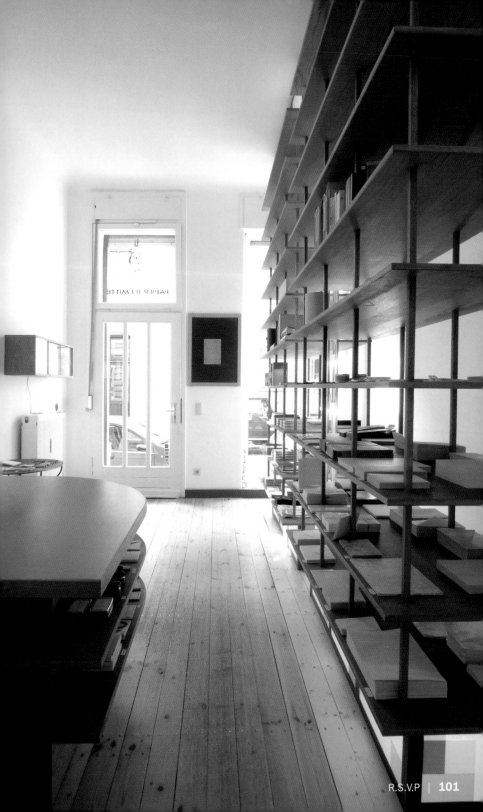

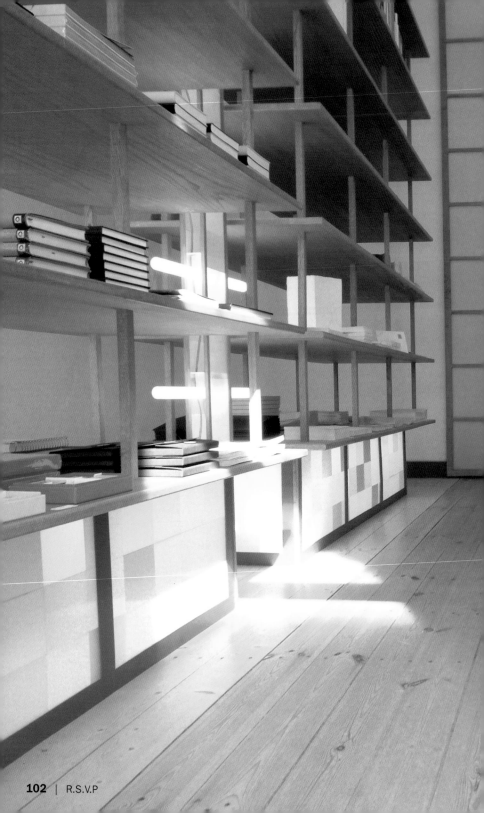

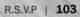

Respectmen

Design: Karin und Alfred Warburg, Dirk Jacoby

Neue Schönhauser Straße 14 | 10178 Berlin | Mitte
Phone: +49 30 2 83 50 10
www.respectmen.de
Opening year: 1995
Subway: Weinmeisterstraße
Opening hours: Mon–Fri noon to 8 pm, Sat noon am to 6 pm
Products: Men's fashion, accessories

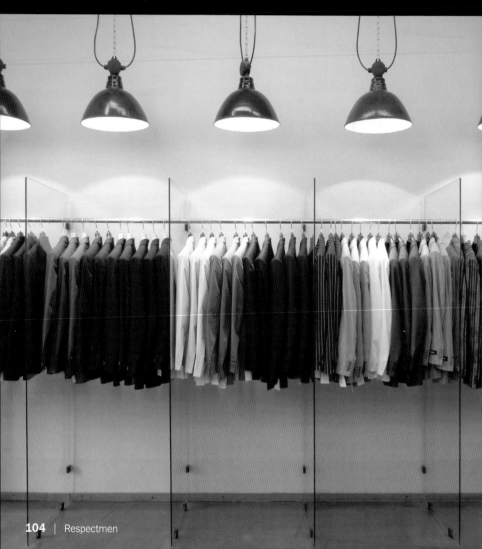

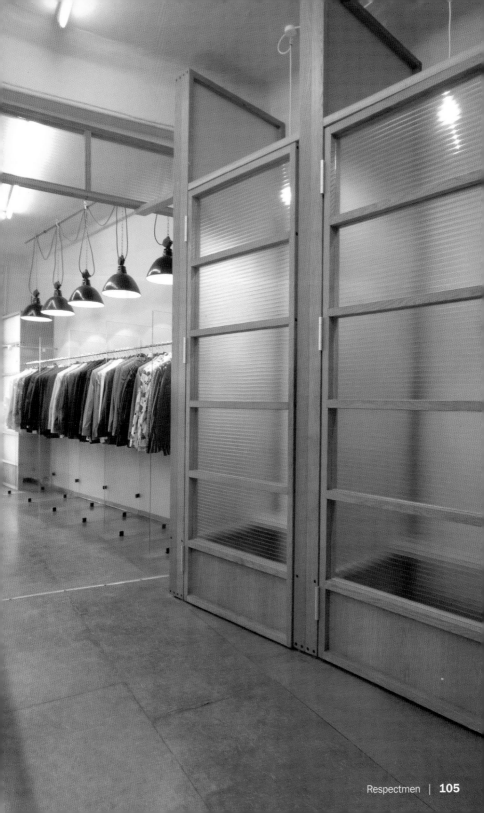

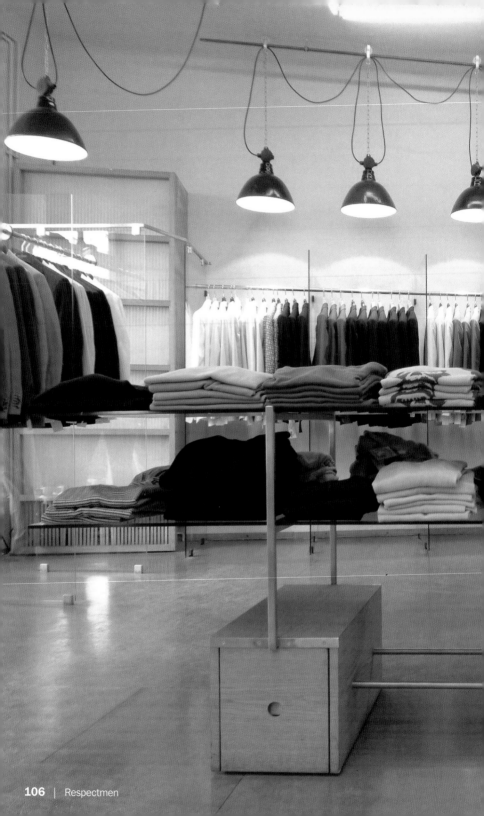

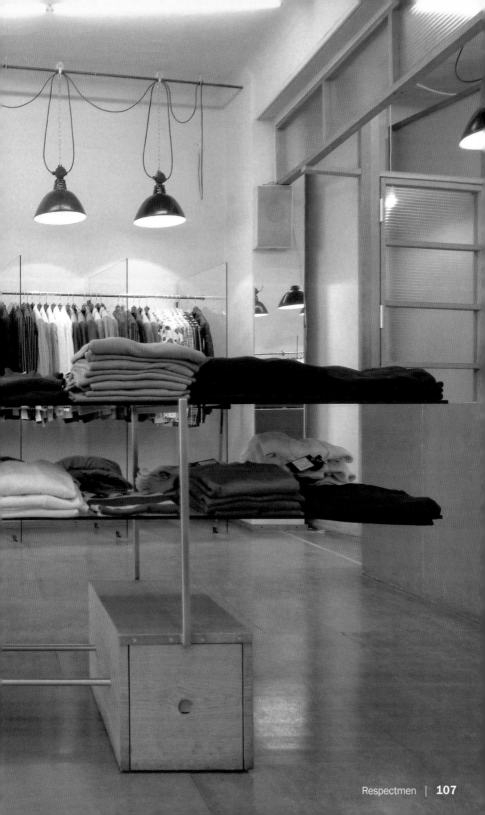

SchmuckAnziehen

Design: Maria Schorr, Julia Stolz

Diedenhofer Straße 4 | 10405 Berlin | Prenzlauer Berg
Phone: +49 30 69 50 91 37, +49 30 41 71 66 96
www.schmuckanziehen.de
Opening year: 2000
Subway: Senefelder Platz, Knaackstraße
Opening hours: Mon 2 pm to 7 pm, Tue–Fri noon to 7 pm, Sat 11 am to 3 pm
Products: Inhouse design and production of silver jewelry with feathers, rare glass or
stones; women's fashion, bridal collection, costume plastics, theatre costumes

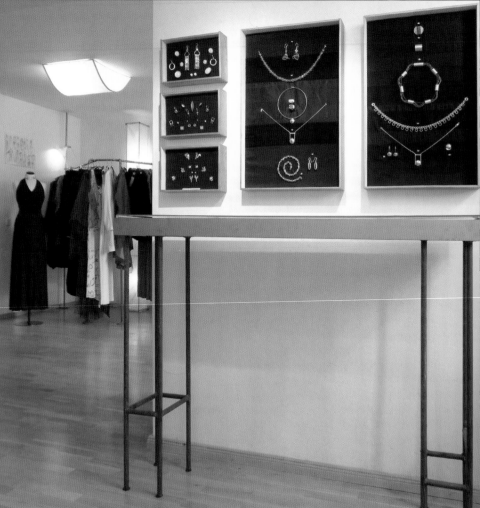

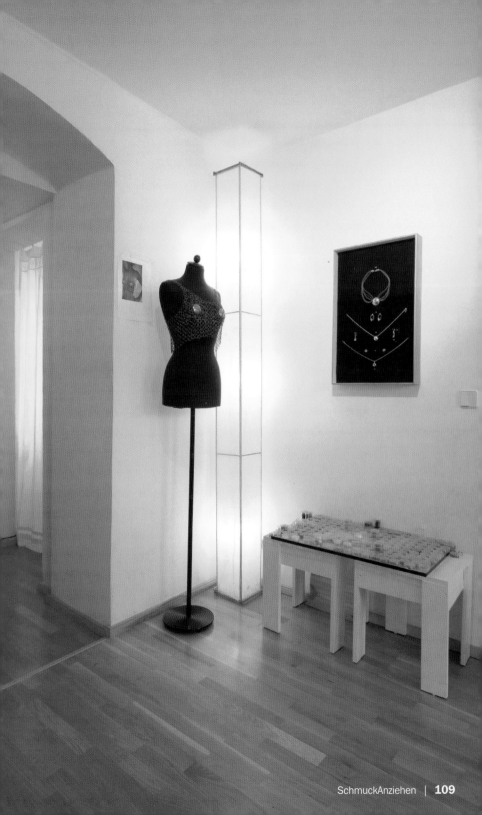

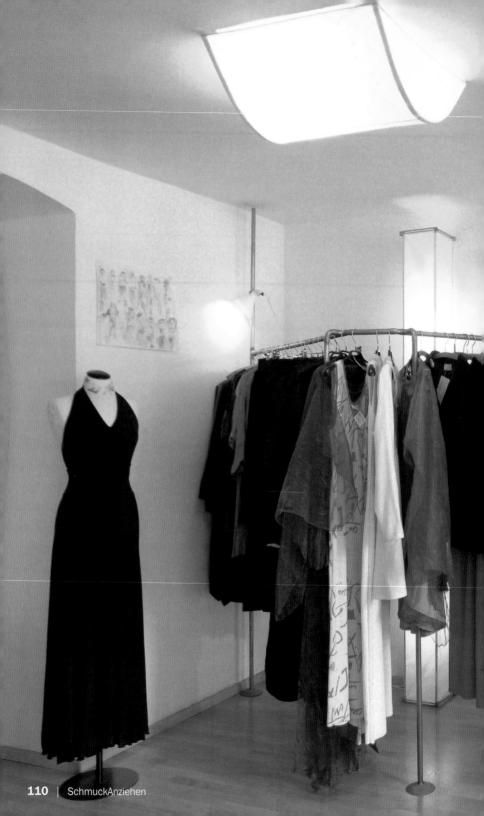

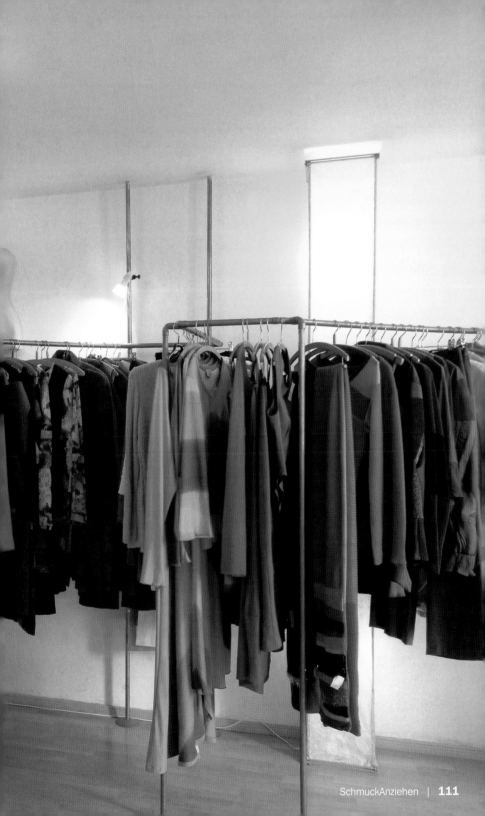

Studio John de Maya

Design: John de Maya, Martin Lischer

Rosenthaler Straße 1 | 10119 Berlin | Mitte
Phone: +49 30 28 38 47 67
Opening year: 1999
Subway: Rosenthaler Platz
Opening hours: Please call for appointment
Products: John De Maya collections

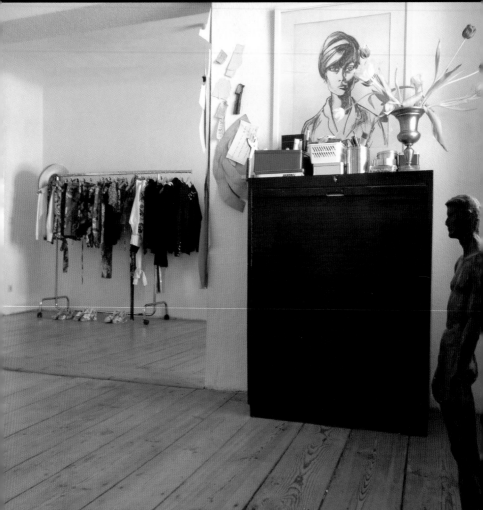

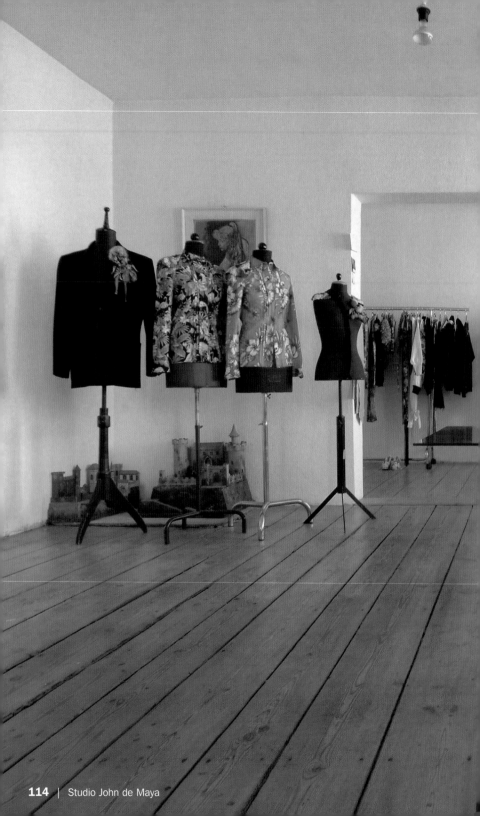

thatchers

Design: Ralf Hensellek & Thomas Mrozek

Hackesche Höfe, Rosenthaler Straße 40–41 | 10178 Berlin | Mitte
Phone: +49 30 4 48 12 15
www.thatchers.de
Opening year: 2002
Subway: Hackescher Markt, Weinmeisterstraße
Opening hours: Mon–Fri noon to 8 pm, Sat noon to 6 pm
Products: thatchers ladies and girls fashion, accessories, CD's
Special features: Musical grooves, affordable clothes

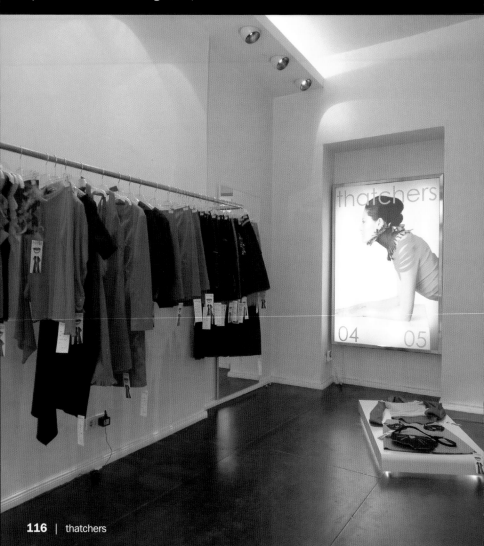

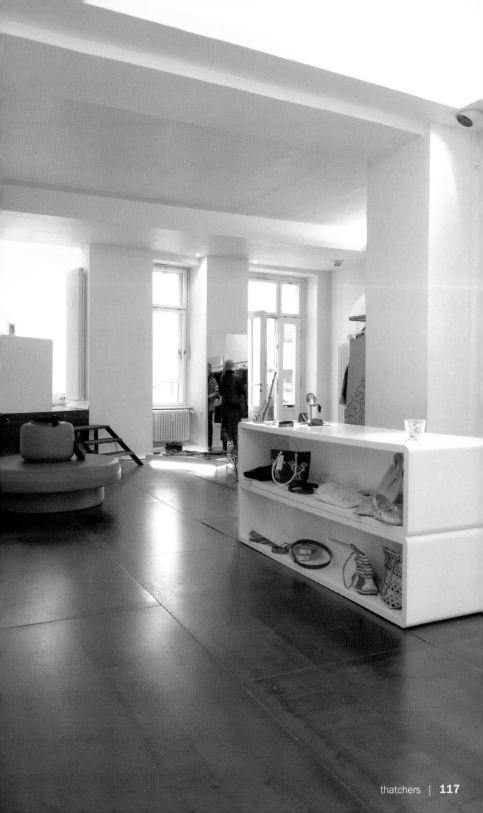

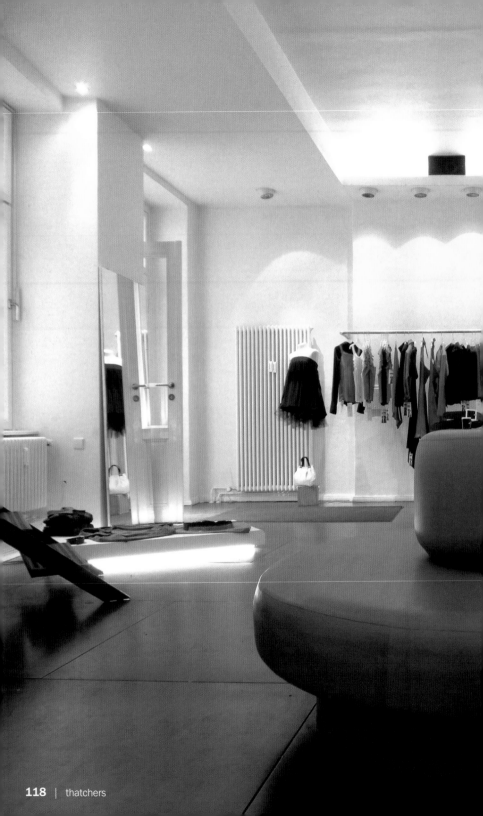

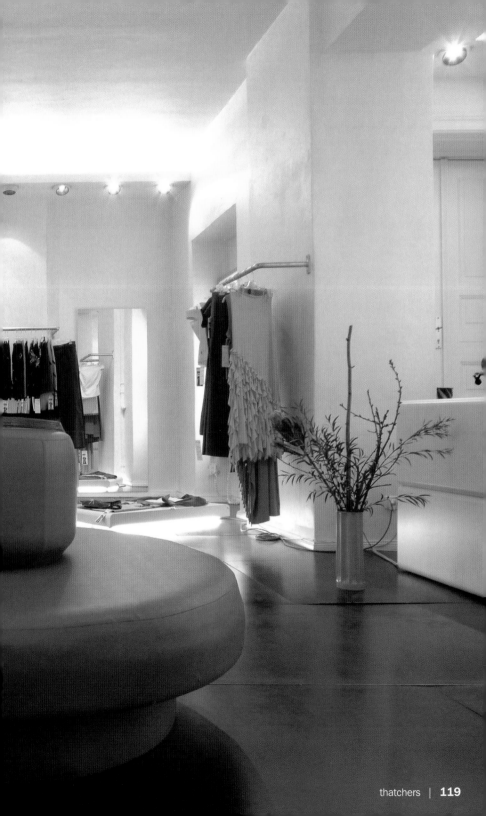

Trippen Flagship store

Design: Michael Oehler, Angela Spieth

Hackesche Höfe, Rosenthaler Straße 40–41 | 10178 Berlin | Mitte
Phone: +49 30 28 39 13 37
www.trippen.com
Opening year: 1995
Subway: Hackescher Markt, Weinmeisterstraße
Opening hours: Mon–Fri 11 am to 8 pm, Sat 10 am to 7 pm
Products: Trippen shoes and accessories

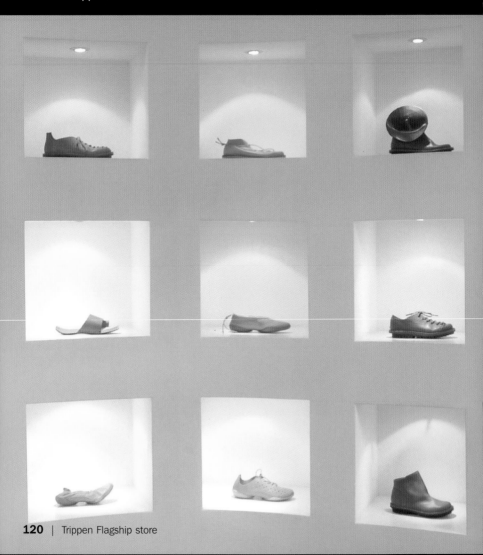

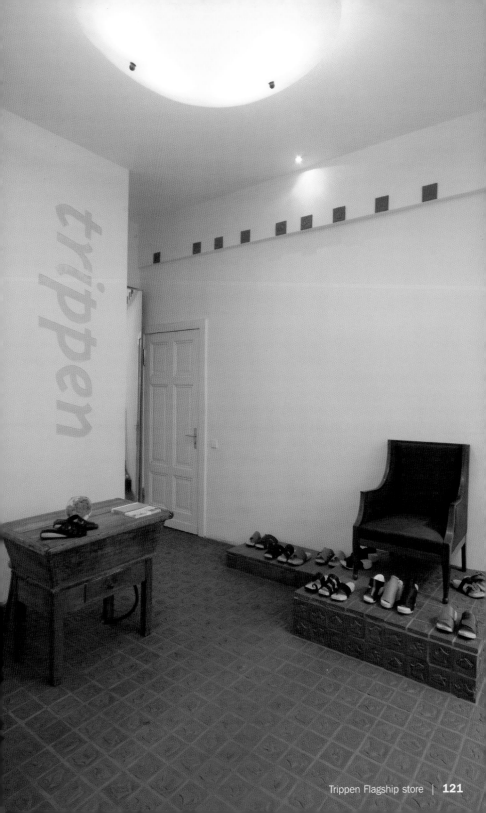

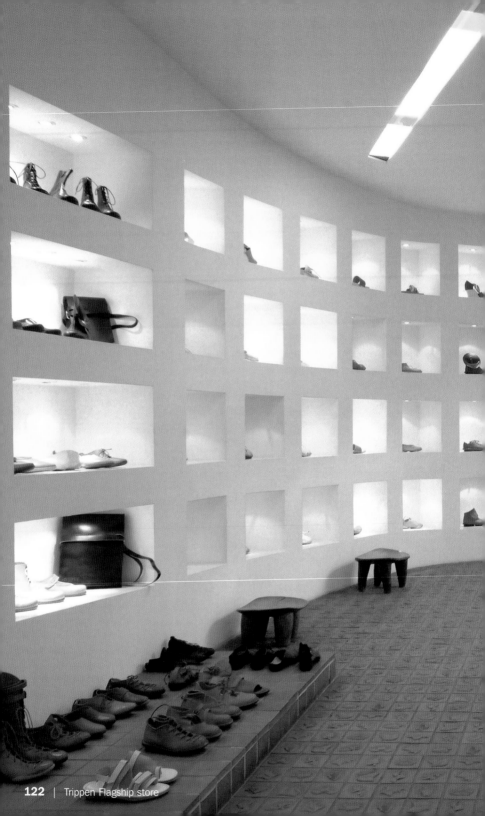

Villa Caprice

Design: Alexander Vögtlin, Ralf Swinley

Dircksenstraße 37 | 10178 Berlin | Mitte
Phone: +49 176 29 51 23 93
www.villa-caprice.de
Opening year: 2003
Subway: Hackescher Markt, Alexanderplatz
Opening hours: Mon–Thu noon to 1 am, Fri–Sat noon to open end
Products: Furniture from Italy and Sweden, fashion, living accessories, drinks,
design products made by Berlin designers
Special features: Bar and lounge, exhibitions, parties

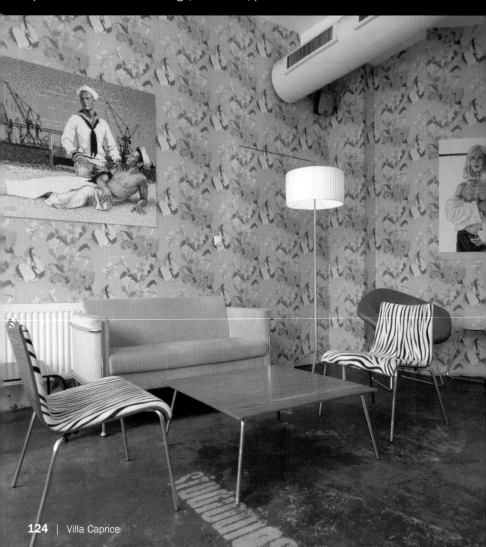

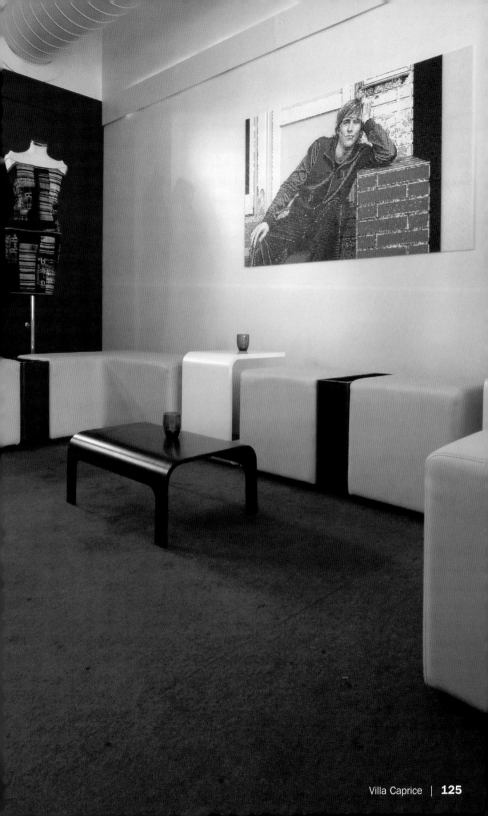

Whisky & Cigars

Design: Stephan Sell

Sophienstraße 23 | 10178 Berlin | Mitte
Phone: +49 30 2 82 03 76
www.whisky-cigars.de
Opening year: 1997
Subway: Hackescher Markt, Weinmeisterstraße
Opening hours: Mon–Fri noon to 7 pm, Sat 11 am to 4 pm
Products: Whisky and cigars, rum, chocolate and accessories
Special features: Tastings, Whisky- and Smoker's night

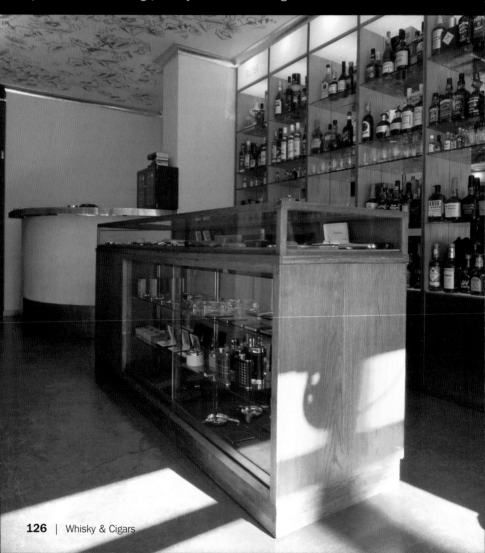

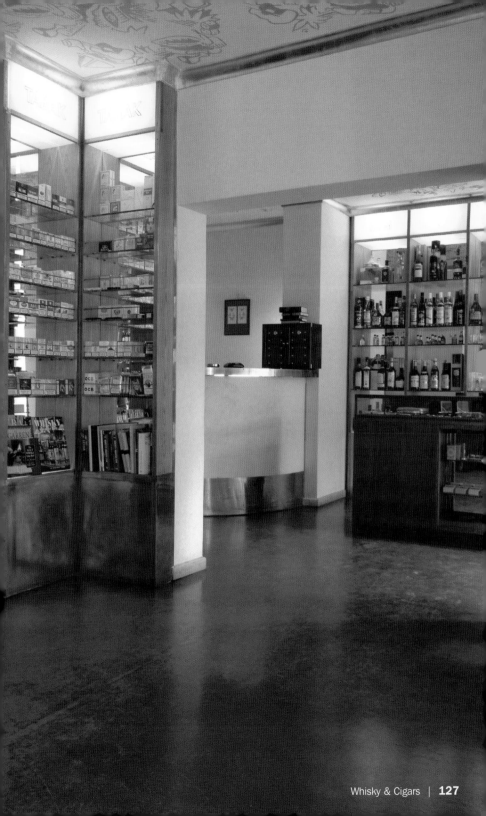

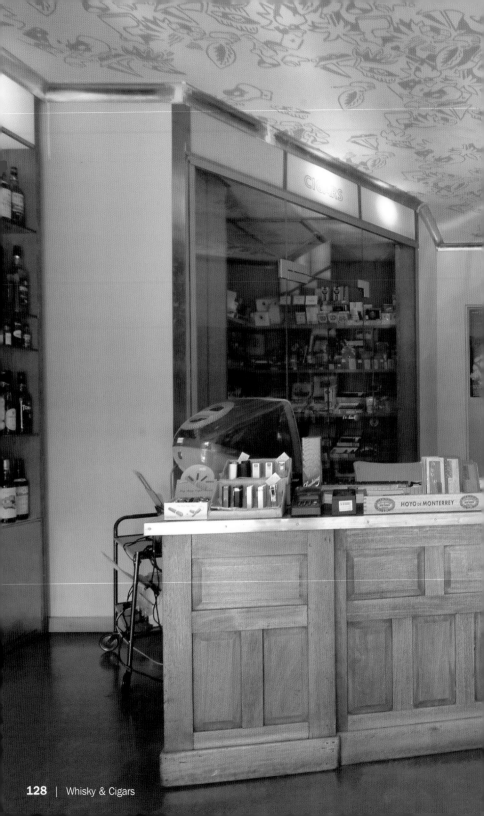

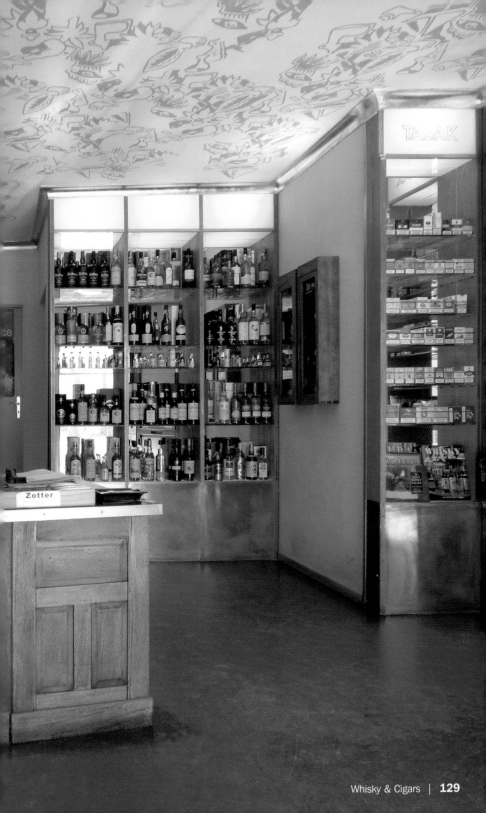

ZUMTOBEL STAFF
Lichtzentrum Berlin

Design: Sauerbruch Hutton Architects

Rotherstraße 16 | 10245 Berlin | Friedrichshain
Phone: +49 30 7 23 97 70
www.zumtobelstaff.de
Opening year: 1999
Subway: Warschauer Straße
Opening hours: Mon–Fri 9 am to 5 pm
Products: Illumination and lighting solutions for offices, shops and industry

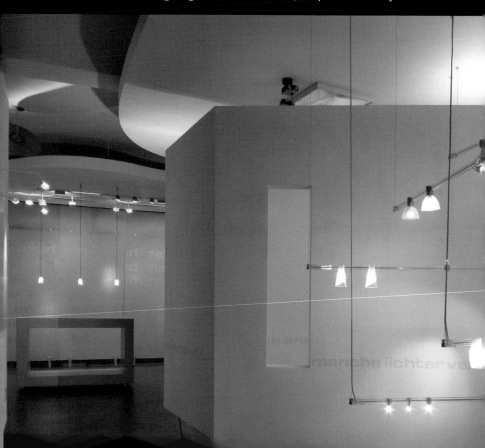

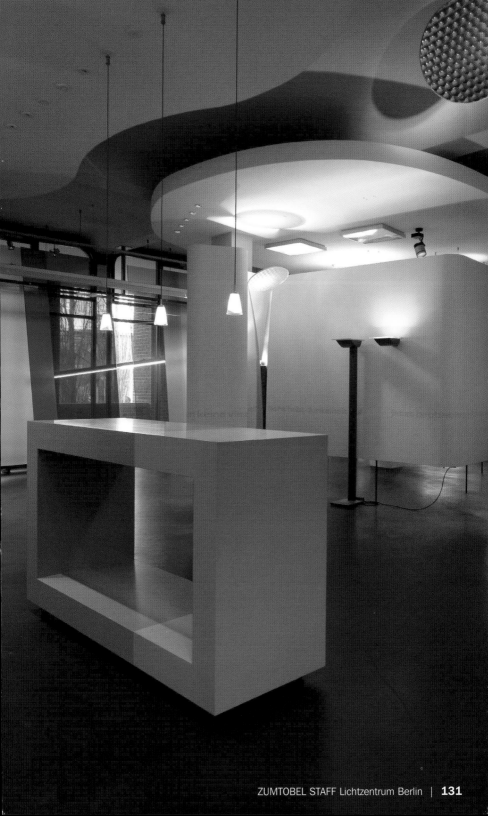

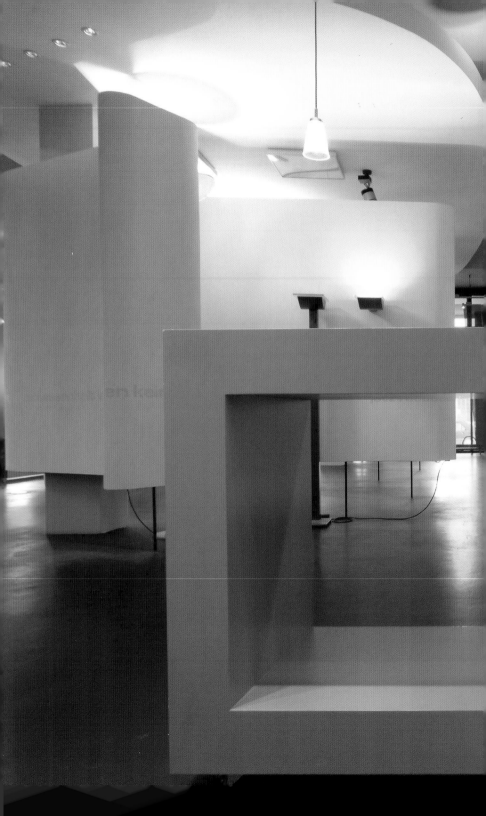

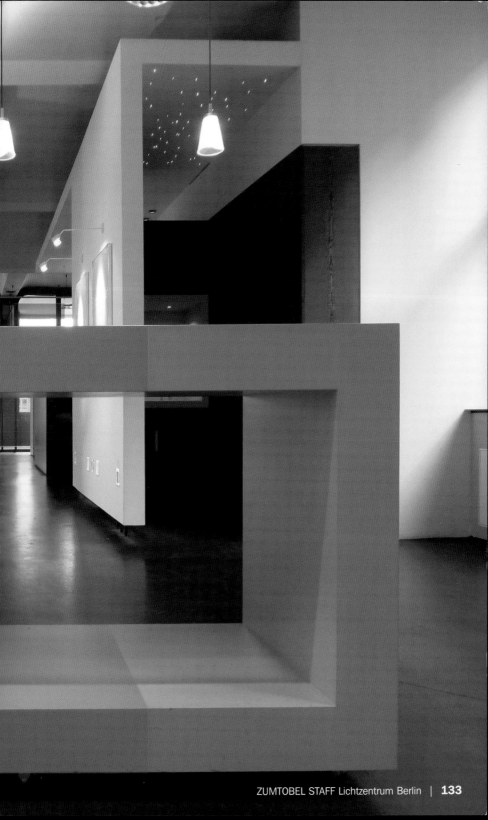

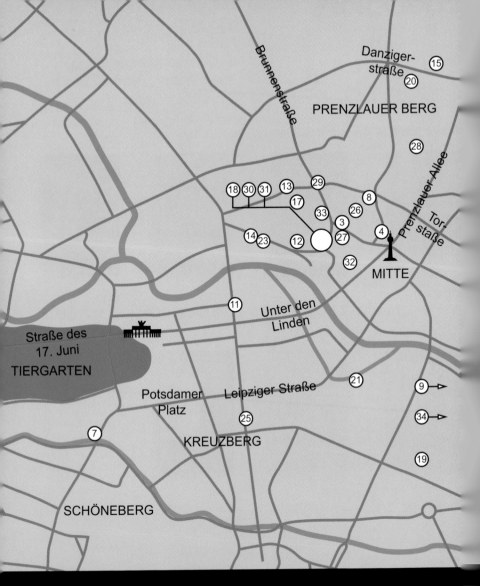

Danziger-straße ⑮
⑳
PRENZLAUER BERG
Brunnenstraße
㉘
⑱⑳㉛ ⑬ ㉙
⑰ ⑧
㉝ ㉖
⑭ ㉓ ③ ④ Prenzlauer Allee Tor-straße
⑫ ㉗
㉜
MITTE
⑪ Unter den Linden
Straße des 17. Juni
TIERGARTEN
Potsdamer Platz Leipziger Straße ㉑ ⑨→
㉕ ㉞→
⑦ KREUZBERG ⑲
SCHÖNEBERG

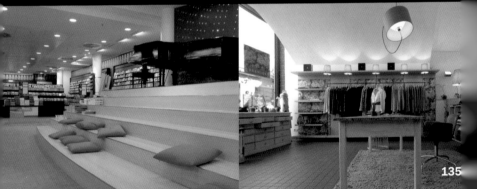